# Exploring Pastel
# with Barry Watkin

# Exploring Pastel
# with Barry Watkin

B T Batsford Ltd, London

## Dedication

To my wife, Pippa, for all her help, encouragement and sound advice.
Without her, the manuscript might never have got to the publishers!

## Acknowledgements

My thanks to the patrons who have kindly given permission for the reproduction of paintings from their private collections, and to Watson-Guptill Publications for permission to reproduce the quotation from *Marine Painting in Oil* which appears on page 80. My thanks also to Lesley Bowe for the many hours spent typing the manuscript.

First published 1996

© Barry Watkin 1996

ISBN 0 7134 8003 3

A catalogue record for this book is available from the British Library.

Published by
B. T. Batsford
4 Fitzhardinge Street
London W1H 0AH

Printed in Hong Kong

# Contents

# Foreword

It gives me great pleasure to write this foreword to Barry Watkin's pastel book. I have followed with interest his progress as an artist for many years and it is most apparent that his joy of painting has not diminished in the slightest. Barry has succeeded in conveying the same commendable enthusiasm in this well-structured and knowledgeable book on pastel painting. Capable of a wide range of expression to suit the style of any artist whatever the subject, soft pastel has no equal. Barry's many colourful paintings illustrated here emphasize the versatility of pastel, and also his ability to capture the mood and atmosphere of a comprehensive variety of subjects.

Most pastellists, myself included, take an opportunity to wave the flag in praise of the wonderful expressive medium of soft pastel, and this book will do much to create further interest. For the newcomer or more experienced pastellist, *Exploring Pastel with Barry Watkin* should have a place on the bookshelf.

**Norman Battershill RBA, ROI, PS**
**Dorset**

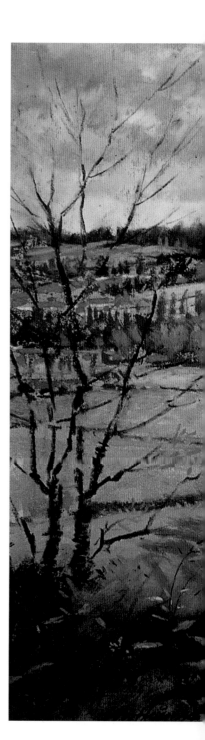

**Dedham Vale from Langham**

356 x 533 mm (14 x 21 in)

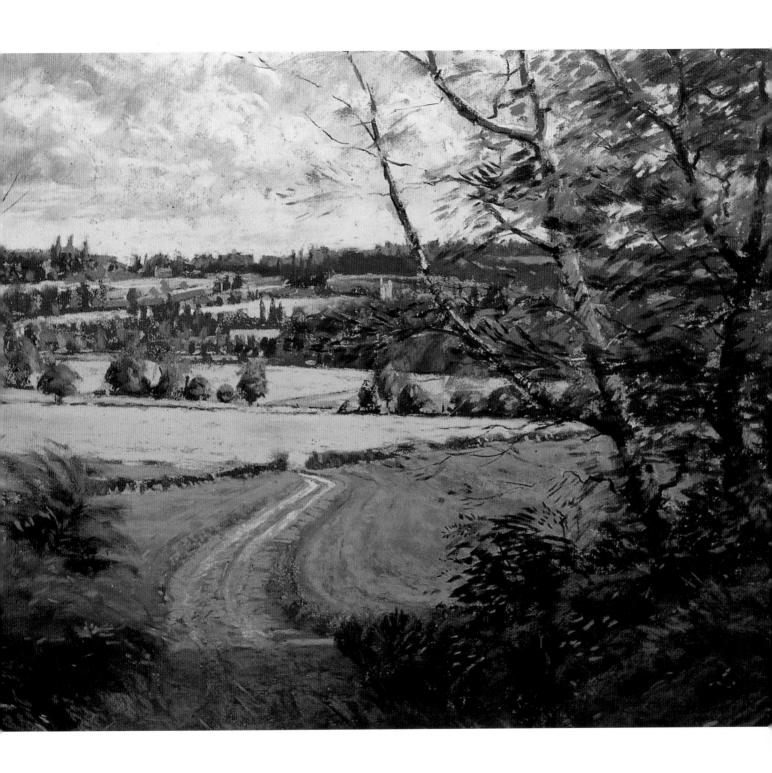

**Looking towards Withypool Hill and the Barle, Exmoor**

533 x 737 mm (21 x 29 in)

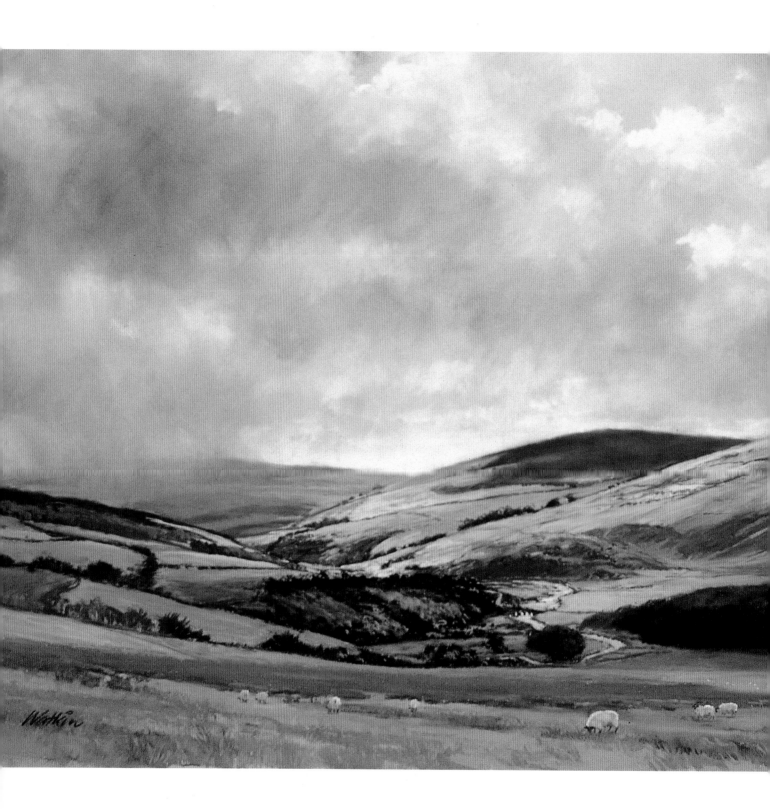

# Introduction

It must have been in 1983 that I started exploring the pastel medium. In June of that year, after 30 years of painting almost exclusively in oils, I was introduced to pastel painting on glasspaper, an example of which, *Dedham Vale from Langham*, is shown on page 7. That day marked a turning point and I have never regretted the switch to this expressive medium.

My wife and family were spontaneous with their approval of my efforts, and the following year two of my pastels were accepted by the RBA at the Mall Galleries in London, as a result of which I was approached by the Blackheath Gallery to exhibit at their Christmas exhibition. Both here and at my local exhibition at the Tadworth Court Hospital I was much encouraged as the red dots appeared and it was then that I decided pastel was for me. I had always worked quickly, and pastel suited my methods perfectly.

In 1988, in order to concentrate more fully on my painting, my wife and I moved to Somerset. The stunning scenery of Exmoor is an inspiration to me, and provides me with much stimulating painting material. The wildness of the place, its big skies, combes and remote sheep farms all offer an inexhaustible range of possibilities throughout the seasons. Typical of this terrain is the area around Landacre Bridge which lies a few miles from Withypool (see opposite).

As I prefer the challenge of direct painting, most of my work is started out of doors. Once I have settled on the main composition and captured the mood, I finish the picture in my studio where I am not influenced by changing conditions.

Over the years my enthusiasm for pastel has grown, and in this I am not alone. During my travels around the world giving workshops and demonstrations I have found more and more people turning to this medium. It is my sincere wish that as a result of reading this book many of you will join their ranks.

# Early Days

Few people realise how long pastel has been used as a means of artistic expression. It could be argued that the early cave dwellers were its first devotees, using compressed pigment in powder form extracted from the earth, from plants and from other sources. Some fine examples of their work can be seen in the caves at Lascaux, France, which go back 15,000 years. However, the use of pastel as we know it was not widespread until the eighteenth century, when its versatility was exploited to the full. In France, it was considered of equal importance to oil. Apparently at one time there were 2,500 pastellists working in Paris alone and Quentin de la Tour (1704-88), the noted Court painter, claimed with some justification that whatever anyone else could do, he could do better – in pastel.

Meanwhile in England, pastel was put firmly on the map by Francis Cotes (1726-70) and his pupil John Russell (1745-1806). Russell eventually became a very successful portrait painter, and his work commanded high prices. In 1777 he wrote a book on pastel techniques, and the medium grew in popularity. Eight years later, in 1785, Russell was given the splendid title of 'Crayon Painter to the Prince of Wales'.

Early pastel portraits can be seen in many of the galleries of Europe and the USA, but there are no landscapes. Perhaps artists disliked working out of doors? As far as we know Simon Manthurin Lantura (1729-78) was the first artist to paint pastel landscapes, although examples of his work are rare.

I was particularly anxious to include a reproduction of an early pastel landscape in this book. I eventually located one at the Rijksmuseum, Amsterdam by the Swiss pastellist Jean Etienne Liotard (1702-90), who worked in England briefly around 1754. His charming painting (presumably worked from his studio) is shown opposite.

By the beginning of the nineteenth century pastel had gone into decline and was seldom used for serious work, viewed mainly as a tool for making quick sketches or for working out a composition. Certainly the Impressionists used it that way, with the exception of Edgar Degas (1834-1917) and Toulouse Lautrec (1865-1901) who exploited the possibilities of pastel to the full, occasionally employing charcoal, conté crayon, ink and other media to create interesting textures and effects.

Nowadays, mostly due to the efforts of the Pastel Society, pastel is making a comeback and people are waking up to the fact that, used as a full painting medium, pastel is the equal of oil, acrylic or watercolour.

**View from the Artist's Studio near Geneva**

450 x 580 mm (18 x 23 in)

An early pastel by Jean Etienne Liotard (1702-90).

By courtesy of the Rijksmuseum, Amsterdam.

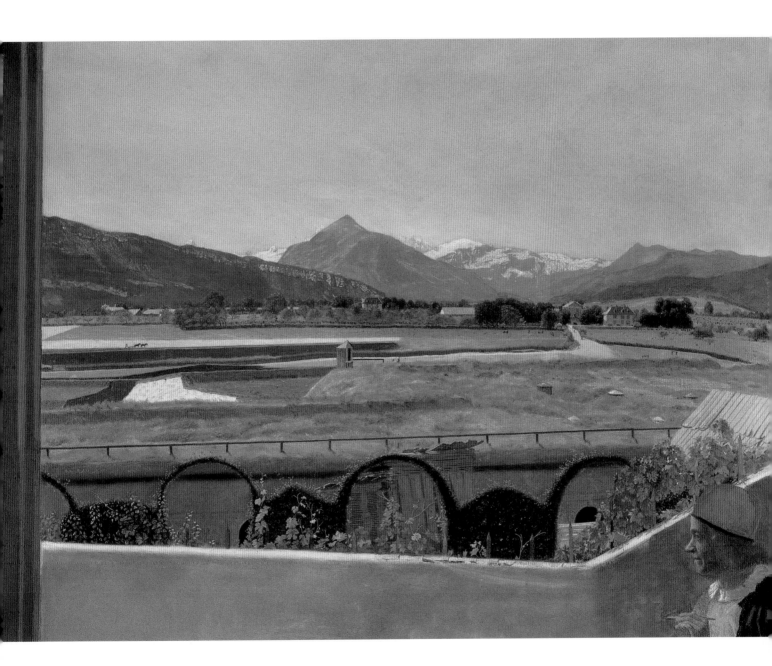

# Getting Started

*Fine Art is that in which the hand, the head and the heart of man go together.*

*John Ruskin (1819-1900)*

These are wise words from a dedicated artist and teacher who reduced the art of drawing to its simplest elements. But before we get too excited about our hands, heads and hearts, we need to look at some of the materials we are going to need and the best way of organizing them.

The author in his studio

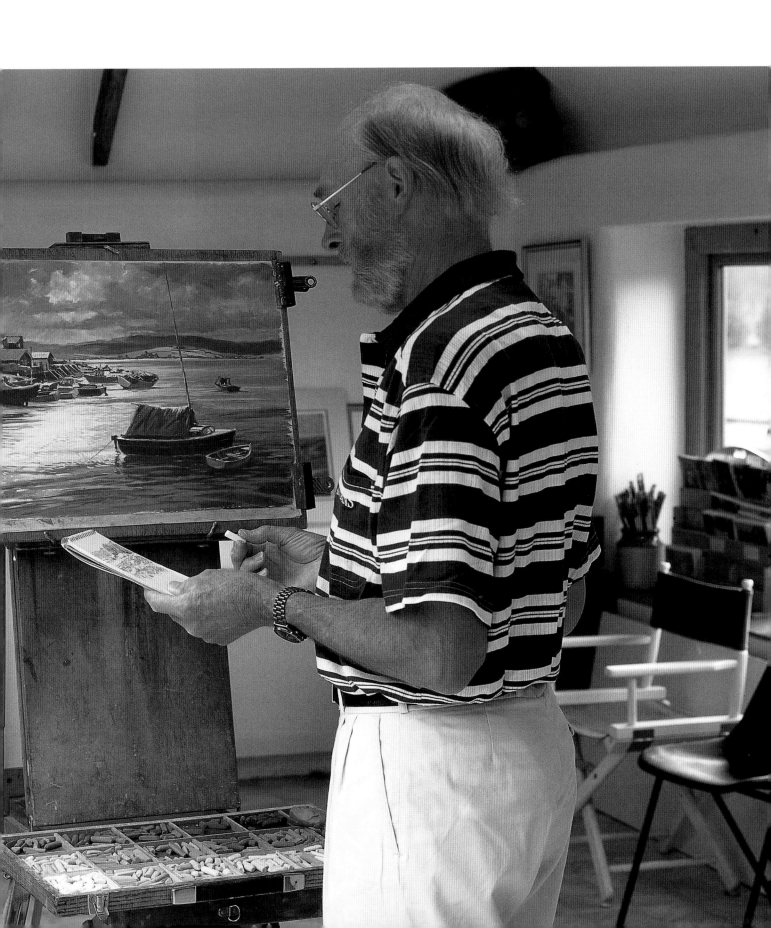

Subject one

# Making Your Mark

Over the years I have frequently observed students hunched, squirrel-like, over yoghurt pots filled with ground rice, vainly trying to distinguish one pastel from another. This can be frustrating, to say the least, and all too often tempers run short, nerves are stretched, and students settle for the nearest pastel that comes to hand. This may or may not be tonally correct, and is hardly conducive to good painting. I am reminded of a lady at one of my pastel workshops who, anxious to have all the right gear, had spent the best part of a tax refund on three huge boxes of pastels. These she spread around her on the floor of the studio, taking up the space of two people and successfully warding off all intruders (including her tutor). By the end of the course I had her working with 40 colours and she was beginning to enjoy herself. Not only that, we all had more room!

## Choosing the Right Pastels

As my story illustrates, it is not necessary to break the bank when starting out in pastel. The choice is broad and what suits one person may not suit another. I prefer soft pastels and I shall confine my comments to these.

### *Daler-Rowney*

For many years I have used Rowney pastels almost exclusively for landscape painting, and I recommend them to my students.

I enjoy the soft, velvety texture of these pastels, particularly the lighter tints, and their size. Because they are quite small, 63 x 9 mm (2½ x ¼ in), they are very easy to handle although the lighter tints are prone to breakage. A disadvantage is that they are rather expensive. The range comes in 194 tints covering 56 colours with 24 colours in half-length broad sticks.

### *Sennelier*

Made in Paris and slightly larger than Rowney, 62 x 10 mm (2¼ x ⅜ in) the Sennelier range comprises 552 tints spread over 83 colours. Arguably the finest selection of pastels produced by any one manufacturer, the range is such that whatever your forte you will find the colour you need and 44 colours are available in giant size sticks 100 x 30 mm (4 x 1¼ in ). Sennelier is the only company to provide really dark darks.

### *Schmincke*

If you want an extremely soft pastel which glides across the paper like velvet, look no further. Handling Schmincke pastels is a truly sensuous experience. Even the darker tones are relatively soft which is most unusual. They are considerably bigger than Rowney or Sennelier, 66 x 12 mm (2¾ x ½ in) and come in 283 tones spanning 56 colours.

**The author's working arrangements**

Pastel boxes (clockwise from left): Unison, Schmincke, Sennelier and Rowney.

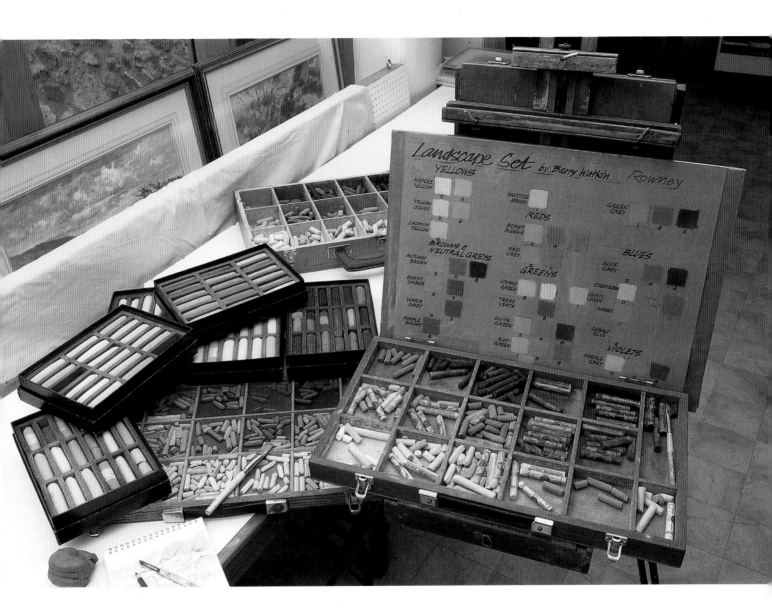

## *Unison*

These are made in England by a family-run firm who, as practising artists, really know their pastels. Over the years I have used their large size pastels extensively for my flower paintings. Slightly harder than Rowney or Schmincke, the range comprises over 260 colours in sets of 18 closely related shades, plus some stunning primaries. All the colours are available in half sticks, 50 x 13 mm (2 x ½ in); large, 68 x 19 mm (2⅔ x ¾ in); and what can only be described as whopper, 115 x 38 mm (4½ x 1½ in). For value for money they are unbeatable and they have the added advantage that there are no fiddly wrappers to remove.

15

## Fig. 1 Recommended pastels

The 40 pastels that I recommend for students attending my courses.

| Rowney | Tint No. | Sennelier | Schmincke | Unison | |
|---|---|---|---|---|---|
| Naples yellow | 0 | 118 | 13-O | Yellow gold | 18 |
| | 6 | 611 | 13-D | Yellow gold | 15 |
| Yellow ochre | 2 | 115 | 28-M | Yellow gold | 6 |
| | 6 | 145 | 28-B | Yellow gold | 2 |
| Cadmium yellow | 4 | 99 | 4-M | Yellow gold | 11 |
| Autumn brown | 3 | 63 | 33-H | Brown earth | 3 |
| | 5 | 510 | 32-B | - | |
| | 8 | 58 | 98-D | Grey | 15 |
| Burnt umber | 2 | 27 | 33-M | Brown earth | 15 |
| | 6 | 193 | 33-D | Brown earth | 12 |
| Warm grey | 5 | 399 | 98-H | Additional | 39 |
| Purple-brown | 4 | 444 | 24-H | - | |
| Vandyke brown | 1 | 64 | 32-O | Brown earth | 13 |
| Burnt sienna | 2 | 72 | 17-M | Brown earth | 9 |
| | 4 | 69 | 17-D | Red earth | 15 |
| Red grey | 2 | 439 | 37-M | - | |
| Lizard green | 1 | 209 | 86-O | Green | 18 |
| | 3 | 205 | 2-B | Green | 11 |
| Terre verte | 8 | 199 | 82-B | Additional | 44 |
| Olive green | 2 | 453 | 85-M | Green | 16 |
| | 4 | 450 | 85-D | Y-gn earth | 10 |
| | 8 | 508 | 30-B | Y-gn earth | 18 |
| Sap green | 1 | 206 | - | Green | 17 |
| | 3 | 316 | 86-D | - | |
| | 5 | 202 | - | Green | 32 |
| | 8 | 169 | 86-B | Green | 15 |
| Grass green | 1 | 277 | 77-O | Green | 24 |
| Green-grey | 1 | 214 | 80-M | Green earth | 4 |
| | 4 | 212 | 94-E | Green earth | 5 |
| | 6 | 210 | 94-D | Green | 13 |
| Blue-grey | 2 | - | 80-M | Grey | 3 |
| | 4 | 422 | 91-H | Grey | 13 |
| | 6 | 500 | 90-B | Grey | 14 |
| Cool grey | 6 | 494 | 90-H | Grey | 8 |
| Coeuruleum | 0 | - | 65-O | Blue-green | 18 |
| Indigo | 1 | 293 | 91-M | Grey | 9 |
| Cobalt blue | 2 | 138 | 64-M | Grey | 10 |
| Purple-grey | 0 | 498 | 90-O | Grey | 6 |
| | 2 | 482 | 90-M | Additional | 32 |
| | 4 | 480 | 90-D | Grey | 7 |

**Fig. 2 Suggested measurements for a pastel box.**

Hinges, catches and handle are by Cheney.

Because pastels can't be mixed on a palette like other types of paint, you will need more of them than you would of, say, oils or watercolours, but you should still be prudent in your selection. It is all too easy to be seduced in an art shop (by big, beautiful boxes of pastels, I hasten to add), and we should be on our guard against these ploys of the marketing people. Better to select 30 to 40 pastels from the cabinet trays. For your guidance I have included my lists of 40 colours suitable for landscape, available from Rowney, Schmincke, Sennelier and Unison (see Fig. 1).

## Keeping Control

Yoghurt pots are out! My pastels are stored in a box which keep them secure in 15 foam-lined compartments. This way I group my yellows, blues, greens, greys and reds graded in three rows through light, medium and dark tones. This keeps my dark pastels away from the light ones and eliminates the chore of cleaning them in flour or ground rice. The lid, by the way, is hinged so that it may be removed from the box when in use. The box, with its measurements, is shown in Fig. 2.

Many students make the mistake of trying to use pastels with the wrappers on which is extremely inhibiting and can result in fussy, fiddly work. For this reason it is advisable to make a chart before you remove the wrappers, labelling each pastel mark with its correct name and number. This chart can be used for easy reference when re-ordering.

## Accessories

You will notice that there is an extra compartment running full depth down the right-hand side of the box. In this I keep the following extras:

Blu-tak/Prit-tak. One packet of each mixed together is invaluable for keeping hands (and therefore pastels) clean.

Sticks of charcoal.

Scalpel for sharpening pastels and pencils.

Two pastel pencils – a black and a brown. No. 10 hog bristle brush for brushing out mistakes.

The only other essential items I carry with me are a sketch book, a 4B pencil, a viewfinder and occasionally an aerosol of fixative. I never fix my finished paintings because fixative darkens pastel. If I use it at all, it is to fix my charcoal monochrome to prevent it sullying the pastel or to give

17

better control when building up layers. When travelling I often carry a set of pastel pencils as an alternative sketching medium. They take up little room and are useful for jotting down scenes quickly. They are also ideal for hatching and feathering techniques on a coloured ground which can produce some extremely interesting effects.

## Choosing Your Paper

Almost any type of support will do provided there is enough key or 'tooth' to hold the pastel.

### Textured pastel papers

Obtainable from most art shops, and probably the most widely used for pastel painting, textured pastel papers are ideal for beginners. The choice is broad with around half a dozen manufacturers producing a bewildering range of colours and tints on a variety of subtly textured, plain or speckled surfaces. All of them are acid free (with the exception of black, which you probably wouldn't choose anyway) with a high rag content in weights varying between 90gsm (grams per square metre)/40lb and 190gsm/90lb. Claims concerning lightfastness should be taken with a pinch of salt. Try placing a sheet of brightly coloured paper in direct sunlight for a week, with half the sheet covered – it is an illuminating experience.

The following are some types of textured papers:

**Canson**
Mi-Teintes. Made in France. 51 colours. 160 gsm. Available in pads, blocks and sheets. Ingres Vidalon. 21 colours. 100 gsm. A laid paper.

**Daler-Rowney Ingres**
19 colours. 90 and 160 gsm.

**Fabriano**
Ingres. Made in Italy. 19 colours. 90 gsm. A laid paper.
Tiziano. 31 colours. 160 gsm.
Roma. 8 colours.

**Goldline**
Tiziano. 31 colours. 160 gsm.

**Hahnemuhle**
Ingres. Made in Germany. 8 colours. 95 gsm.
Bugra Butten. 15 colours. 130 gsm.

**Winsor & Newton**
Artemedia. Various colours. 170 gsm.

All of these papers have slightly different surfaces and most are available in pads, blocks or sheets. Sample them until you find one which suits. My own favourite is Canson Mi-Teintes (the smooth side) with Winsor & Newton's Artemedia a close second.

A sketch executed on the textured surface of the 'correct' side of
Canson Mi-Teintes paper. Try the other side.

## Synthetic surface pastel board

Rembrandt, Sennelier and Schminke make
this, the one by Schmincke going by the
name of Sansfix. All three have their pastel
boards manufactured by a company in
France. They market them under their own
brand names but the surfaces are identical.
I have a love/hate relationship with this
board. I like its size, 650 x 500 mm
(25½ x 19½ in), which is slightly squarer
than standard imperial formats and ideal
for larger paintings. It is quite thin and
remains flat. However, I am less
happy with its artifical surface which
holds the pastel so rigidly that it is
difficult to blend colours smoothly.
Also, heavy applications of pastel will
sometimes 'lift off', rather like plaster
falling off an old wall.

The boards come in a range of 14 colours.
Should your board get wet, allow it to dry
before making good, or you will find the
synthetic surface will lift off and the card
underneath will not take pastel.

19

**Two Barns in Sussex**

483 x 635 mm (19 x 25 in)

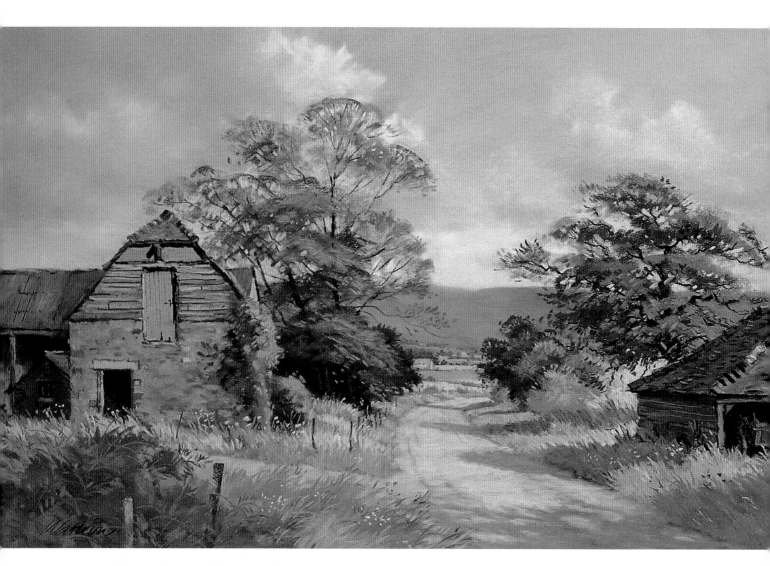

This product is rather expensive (nearly four times the price of an equivalent sheet of Canson).

## *Industrial surfaces*

Until recently 00 Grade glasspaper was obtainable in imperial sheets through a few suppliers in the UK. Fortunately an excellent alternative has been found in the shape of Hermes P400 Finishing Paper, which almost matches the original glasspaper for smoothness of tooth.

The number denotes degree of tooth so that the higher the number, the finer and smoother it is. Hermes P400 is superior in that it is produced on a slightly heavier paper which has eliminated 'waving'. Its fine, abrasive surface takes a lot of pastel, thereby producing a painting which will be totally permanent as well as providing the work with a brilliance and power that is unobtainable on other surfaces. Occasionally I rub lightly over the surface with a small offcut to reduce its sharpness.

20

**Fig. 3 Pastel box shelf**

This modification requires two holes to be drilled through a Frank Herring easel.

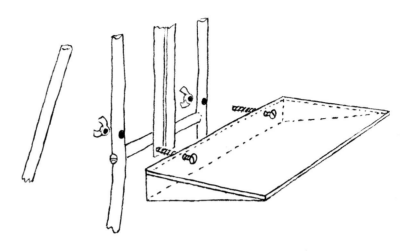

Hermes is not generally available through art shops – although the situation is improving – but it can be obtained in imperial sheets, dry mounted on board, or in rolls, from art suppliers.

## Easel and Board

To avoid 'getting plastered', a suitable easel must be found. Working with your board flat on a table or on your knees invariably results in sleeves or cuffs dragging across the surface of the painting. There are plenty of easels on the market, but the one I have no hesitation in recommending to my students is the Frank Herring Versatile Easel, which, as its name implies, can be used for oil, watercolour or pastel. It is light, very stable, and fully adjustable. For those who prefer to stand while painting, Herrings will supply a small pastel box with six compartments which can be attached to the easel with a simple bracket. For my own larger box I have devised a simple tray which is bolted onto the front of the easel by means of two holes drilled through the front supports (see Fig. 3). The Frank Herring Versatile Easel is available from most good art shops, or Frank Herring and Sons (see page 126).

In 1993 I travelled to Australia with this easel, special tray, pastel box and papers stowed neatly in the bottom of my suitcase. My only mistake was not wrapping my pastel box in a plastic bag; on arrival at Sydney I found pastel dust had seeped out and changed the colour of my underwear!

For transporting pastel paper or finished paintings, use two sheets of hardboard 41 x 61 cm (16 x 24 in). Place the paintings on the bottom board, one on top of another with a sheet of layout paper (A2) between each. Finally place the top board over the sandwich and tape it down at all four corners, thereby preventing any movement during the journey.

To complete your equipment you will need a board 390 x 570 mm (15¼ x 22¼ in) which will take a half imperial sheet, and six layers of newspaper, slightly smaller, held in position with four large metal clips. The newspaper acts as a cushion to the painting, but must be ironed absolutely flat before use.

21

Subject two

**Rockface near Sampford Brett**

407 x 610 mm (16 x 24 in)

Painted on 3M Wetordry paper.

# Choosing Your Subject

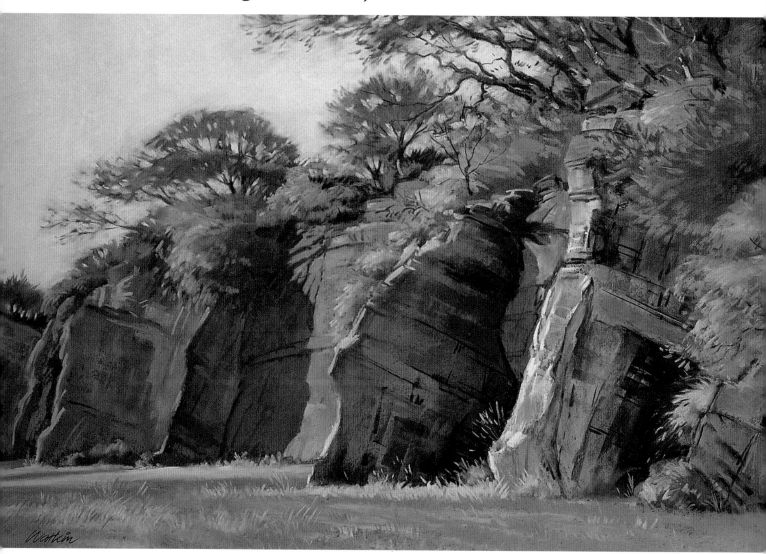

## Composition

The choice of subject is wide and varied, and may be determined by circumstances or personal preference. I cannot over-emphasize the importance of a viewfinder as an aid to composition. We must develop the habit of looking at all the possibilities before committing ourselves to one particular viewpoint or format. Walk around, observe and try to find the most interesting angle on the subject. Make a few thumbnail sketches as you go – they will not take very long – and then eliminate the views of the subject that don't seem to work.

22

## Fig. 4 Establishing the focal point

**Top left:** concentrating the lightest light against the darkest dark on a prominent feature in a landscape will draw the eye to that area.

**Top right:** the church tower and cottage at the end of the street form a natural focal point and the dark bush against the light wall provides the necessary punch.

**Bottom left:** the tightly knit group of mirror, jug and brandy glass holds the eye, balanced by the three objects to the left. Folds in the drape and cloth lead the eye into the picture.

**Bottom right:** animals and birds always draw the eye. The clutch of hens against the steps is counterbalanced by the window.

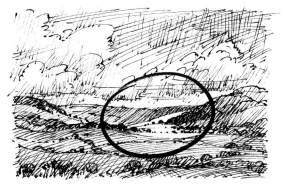 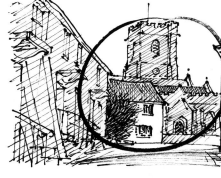

a Light source from the right.         b Light source from the left.

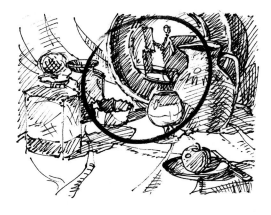 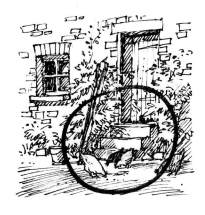

c Light source from behind the subject.         d Light source from behind the viewer.

First, establish the focal point, or centre of interest, something that excites you and which will draw the eye (see Fig. 4). This should be balanced by something of secondary interest, either to the left or right, depending on the location of the focal point.

Next, decide on the proportions of land and sky in your painting. With a big sky, the landscape can be relegated to as little as one quarter of the picture area.

The time of day is critical. What works in morning sunshine may look very ordinary later in the day.

Light and shade play an important role in establishing the success or failure of a picture. They describe the form of objects and give punch and contrast to the painting.

23

**Fig. 5 Four angles on a landscape**

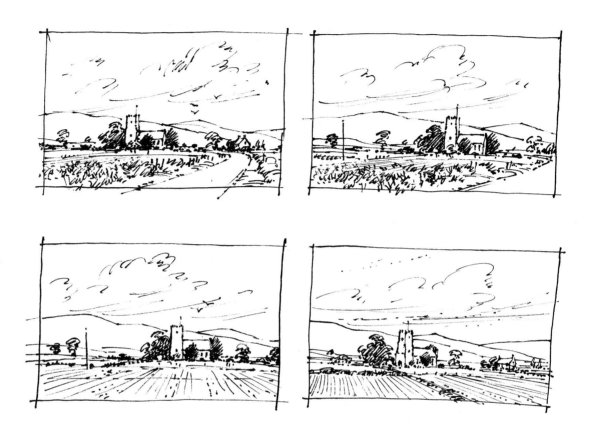

In Fig. 5, I show a landscape sketched from four angles. Which would you choose? There is no doubt in my mind that the first sketch holds together much more satisfactorily than the other three. The lane swings the eye in towards the church, the buildings are at a pleasing angle and the hedge creates foreground interest as well as hiding some of the field behind it. There is also a good range of tones, with the dark trees contrasting nicely with the light church.

## Time of day

Now let us consider the position of the light source in relation to the subject. This can have a dramatic effect on the final result and may enhance or actually ruin an otherwise excellent composition. Opposite are four sketches (Fig. 6a-d) of the same subject made at different times of day, all giving very different results.

Which sketch seems to offer the most interesting play of light and shade? To my mind, Fig. 6b illustrates perfectly my point about waiting for the right time of day. The light wall contrasts strongly with the dark entrance and the cast shadow points towards it. Additional contrasts are provided by the dark tree behind the light roof, the end gable against the background trees and the wall below it. The wall to the right of the track creates a very interesting shape against the barn behind.

24

**Fig. 6 Time of day**

a Light source from the right.

b Light source from the left.

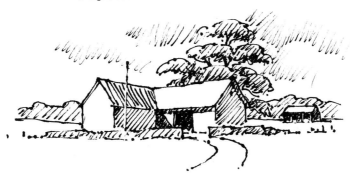

c Light source from behind the subject.

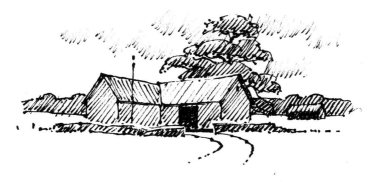

d Light source from behind the viewer.

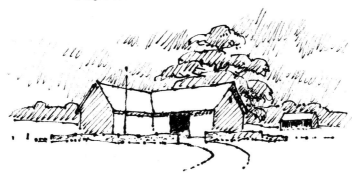

**The Mountains of Killary Lough, Connemara, Ireland**
356 x 533 mm (14 x 21 in)

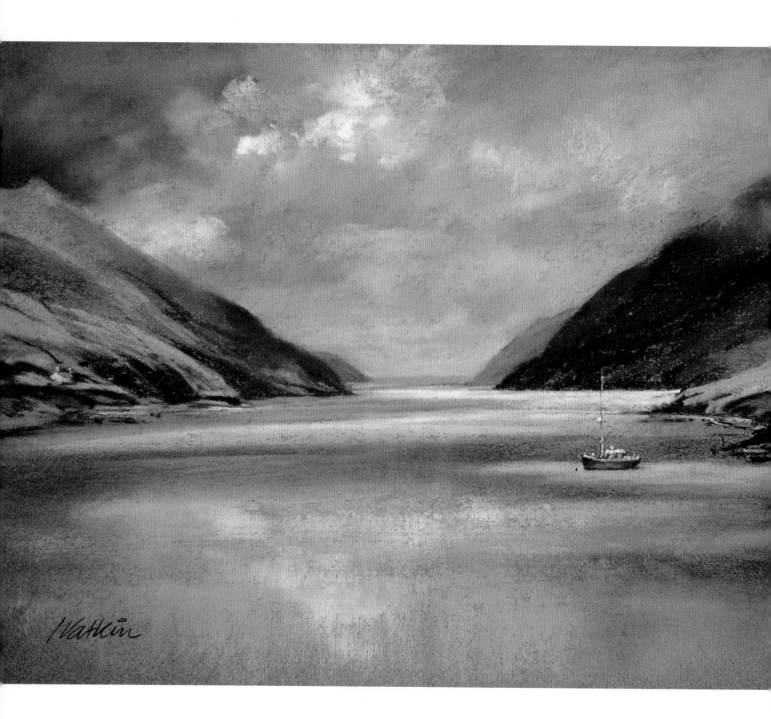

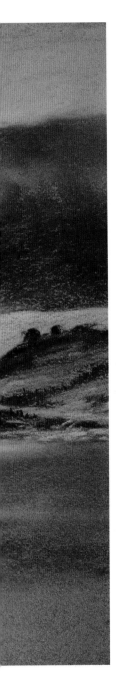

**Fig. 7** The viewfinder is the best (and cheapest) aid to composition.
Here it is used to locate the most interesting section of a panorama.
An alternative view is shown inset.

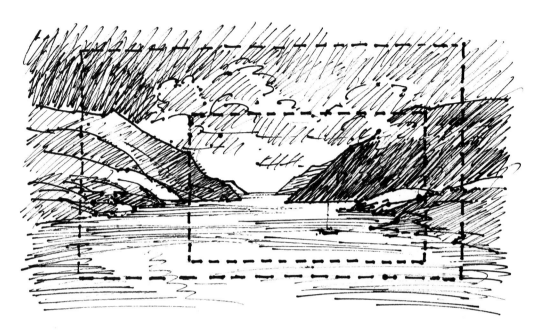

## Composing your picture

Try to develop the habit of working in clearly
defined stages. This practice snuffs out
indecision, increases confidence and
realizes better results. Sometimes hills and
mountains act as a backdrop to the focal
point (see my painting *The Mountains of
Killary Lough, Connemara, Ireland*). The
large mountain on the right is placed in
shadow to emphasize the light on the
water and the small headland below. The
fishing boat at anchor makes an obvious
focal point, balanced by the tiny cottage
on the opposite shore. Note the big cloud
reflected in the still water. Selecting your
cut-off points is not always easy when
faced with a large panorama and a view-
finder is invaluable to help you make your
decision. Two possibilities are shown in
Fig. 7. In the end I felt the larger area
captured the grandeur and mood of the
scene more effectively.

27

# Landscapes

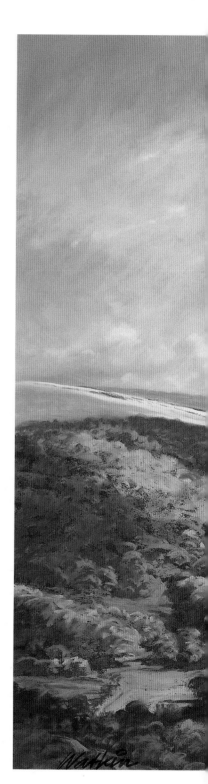

*I have seen dawn and sunset on moors*
*and windy hills coming in solemn beauty like*
*slow old tunes of Spain.*

*John Masefield (1878-1967)*

One of the great things about landscape painting is that it teaches us to observe, to soak up the atmosphere and become aware of the beauty of nature around us. Many of you who live in towns or cities would do well to find one or more like-minded friends and venture away from overly familiar and predictable scenery. Do your homework with a map before you set off, pack your gear and some lunch in the car and see what the day will hold.

**Buzzards over Weir Water, Exmoor**

533 x 737 mm (21 x 29 in)

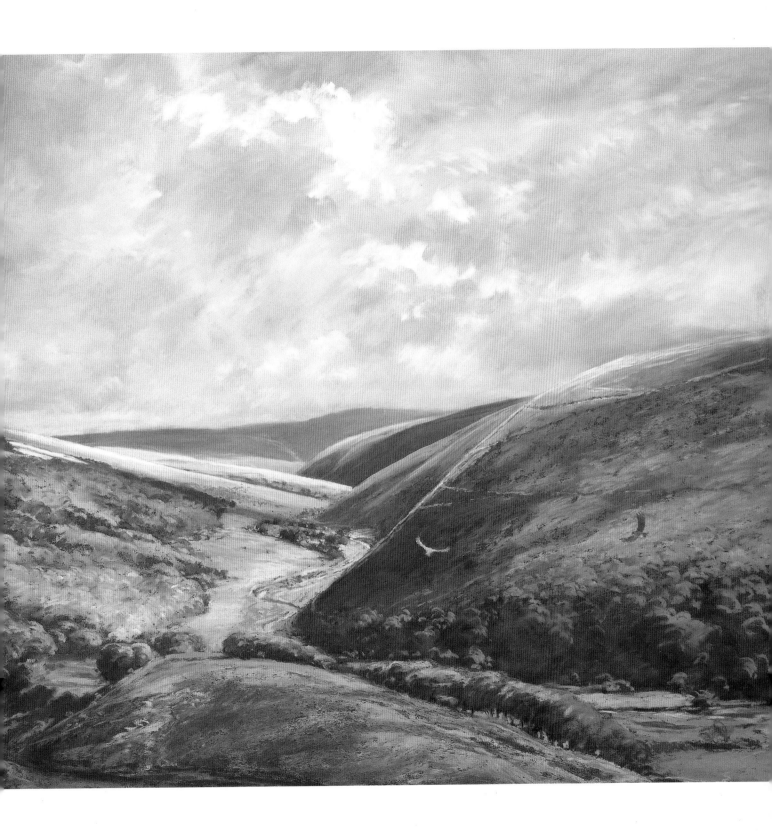

Subject three

# Skies

The trouble with skies is they don't hang around. Like a kaleidoscope, their ever-changing forms dance their way across the sky and create a moving pattern of light and shade over the undulating countryside.

In *Clouds over Box Hill, Surrey* I used cloud shadows to provide contrasts where I wanted them, particularly the main one directly behind the sunlit farmhouse where the near complementary colours of deep blue-grey and orange gave the farmhouse some necessary punch. Another cloud shadow in the foreground concentrated the light around the focal point.

A sky will alter according to the time of day. The best time for painting tends to be early morning or late afternoon when we often get a wonderful quality of light and long descriptive shadows. Around noon, when the sun is at its highest, everything looks flatter and less interesting.

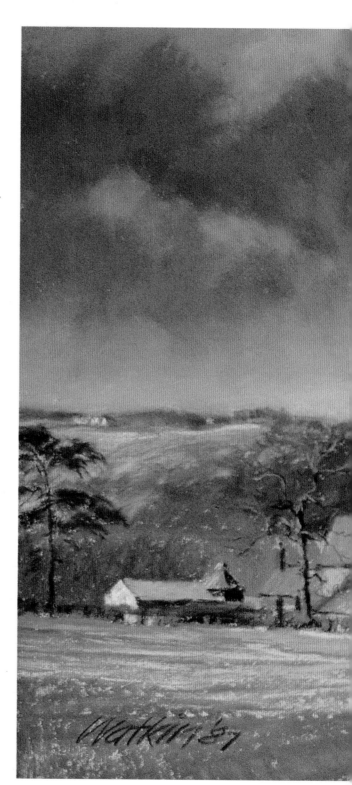

**Clouds over Box Hill, Surrey**
356 x 533 mm (14 x 21 in)

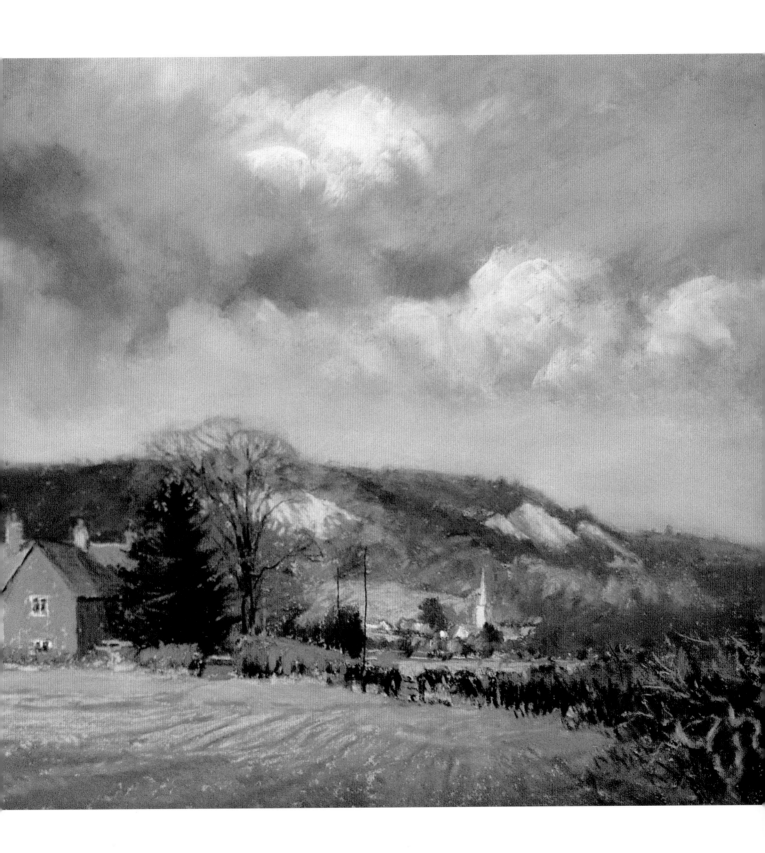

**Buzzards Circling over Nettlecombe**
356 x 533 mm (14 x 21 in)

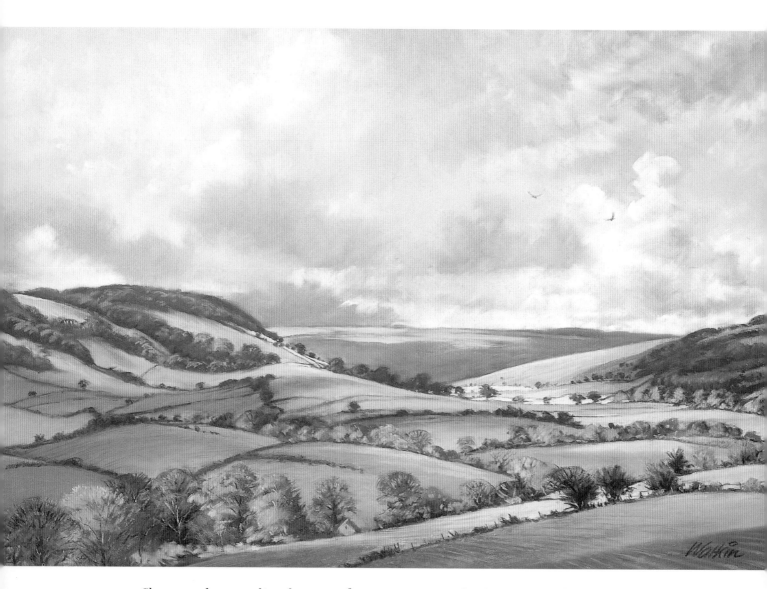

Close to where we live there is a fine view towards Exmoor from the top of a hill above the village of Monksilver. I often take my students there for a 'distant view' with a big sky. The morning I painted *Buzzards Circling over Nettlecombe*, I was blessed with large cumulus clouds casting strong shadows over the undulating landscape below. A suggestion of high cirrus running diagonally across it leads the eye into the picture.

A very different sky is shown in *Sunset, Flooded Levels, Somerset* (see opposite), which I painted on a November evening in 1994 during a blustery Force 6 gale.

**Sunset, Flooded Levels, Somerset**
356 x 533 mm (14 x 21 in)

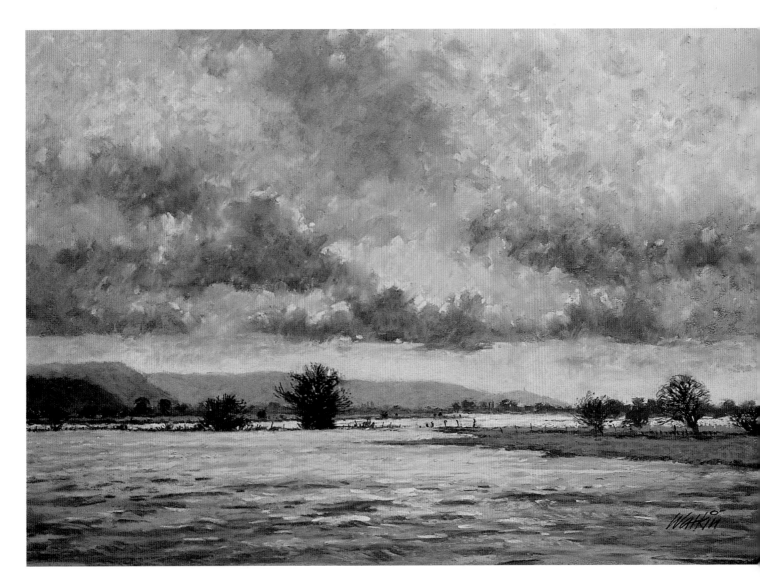

The sky was magnificent and with the light fading quickly I concentrated on its main shapes and colours, placing the area of yellow light just right of centre, thereby counterbalancing the main tree which was the focal point of the picture. After 45 minutes the headlights of a passing car reminded me that it was nearly dark, so I packed up and retreated to the warmth of my studio. The painting was completed using a wide range of Schmincke pastels and the broken colour method (see page 112 for more about this) in order to achieve atmospheric colour harmony.

33

a  Fair weather cumulus

b  Cumulus

d  Stratocumulus

e  Altocumulus

## Painting Clouds

Clouds are just so much vapour, and have a nasty habit of disappearing before your very eyes. A stiff breeze can blow them across your sky and out of sight almost before you can get pastel to paper.

With this in mind it is as well to spend a little time studying the shape and form of the most usual cloud formations before you start putting them into your landscapes.

When a particular scene catches your eye and you want to sketch it quickly, do remember to place the clouds accurately and note the direction of the light. This information will be invaluable when you come to do your painting.

Not every landscape painting requires clouds. Occasionally a busy scene lends itself to the simple addition of a nice warm glow, with plenty of pale yellows, and only a smidgen of blue or purple-grey. When smoothed in, which has the effect of making it sit back, it can harmonize your landscape where a textured, elaborate sky could not.

c Cumulonimbus

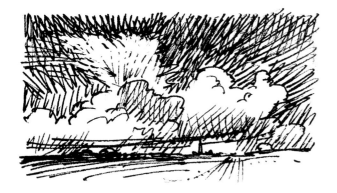

f Cirrus

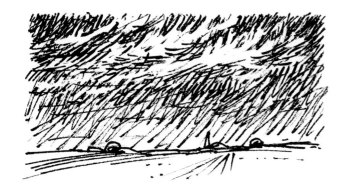

### Fig. 8 Cloud patterns

#### Cumulus (a/b)

Fair weather clouds. Low-flying and usually seen in summer. Small and very light in tone with well-defined tops and flat bases. Can develop into larger clouds, sometimes rising thousands of feet from flat base to characteristic cauliflower tops.

#### Cumulonimbus (c)

Stormy weather clouds. A development of the large cumulus, often towering to 30,000 ft or more and noted for their fibrous top, or 'anvil', caused by high altitude winds. Their bases can get very dark and if one should head your way, be ready to run for cover.

#### Stratocumulus (d)

Flat, low clouds. They usually cover the whole sky, in broken irregular lines, or rolls. Sometimes the patterns merge together to form sheets. Useful if you want a quiet sky for an otherwise busy landscape.

#### Altocumulus (e)

Medium height, dappled cloud. Often referred to as a 'mackerel' sky, altocumulus is flat, with clearly defined shapes comprised of tiny globules. Ideal if you want to create strong patterns in your sky.

#### Cirrus (f)

Very high-flying cloud. Wispy lines, sometimes referred to as 'Mare's Tails'. These feathery streaks sometimes merge into more opaque shapes. Very directional and can be used to counteract a strong diagonal in the landscape, or can be included with large cumulus.

# Demonstration: Sky

**Paper:** Canson Mi-Teintes, pale green-grey
(No. 343) 160 gsm
**Pastels:** Rowney

## Stage 1

As this was a studio painting I had to
visualize the type of sky I wished to
portray. I decided upon heavy cumulus
over distant hills and lightly indicated
the main lines of the composition with
blue-grey, using the side of the pastel
to block in the middle and dark tones.
This established my monochrome. All
the time and at each stage I was mindful
of the direction of light (coming from
top left) which influenced the modelling
of the clouds.

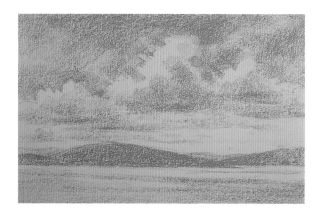

## Stage 2

I added purple-grey to the dark areas leaving
the paper for the lighter passages and
introduced Vandyke brown and yellow
ochre for the light above the horizon.
In order to unify the painting I added
hints of the same into the clouds and
foreground sea. Over this I suggested
patches of blue between the clouds and
cooled the distant hills using indigo. The
lightest area of the clouds was established
with yellow ochre and the half tone areas
with purple-grey.

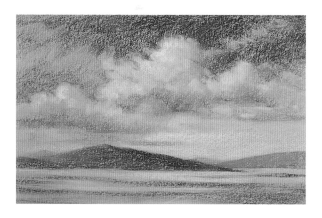

## Final stage

These broad statements now needed to be
developed. Form was given to the main
clouds using purple-grey and other areas
of the sky and hills were warmed. The sky
to the right now looked too pale and was
strengthened with purple-grey, at the same
time using this to indicate a few cloud
bases. Returning to Vandyke brown and
yellow ochre I warmed some of the clouds
and worked a heavier application just
above the horizon. This had the effect of
making the light areas of the clouds look
too dark so I punched in some yellow
ochre. I raised the value of the dark area of
the sky (top left) with indigo and added
touches of the same to the shadow side of
the clouds and distant hills.

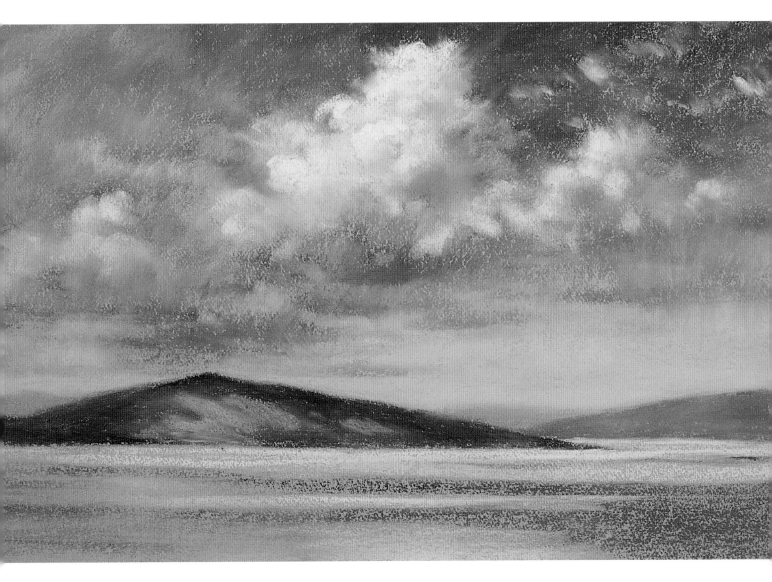

Finally I indicated a strip of light on the water just below the hills, as well as adding a glow to the hillside where the sun was breaking through the clouds. Strengthening the cloud shadow in the foreground helped to hold the bottom of the picture. To aid recession I rubbed in the sky on the horizon and softened some of the clouds and distant hills.

37

**Galahs over Eucalyptus Trees, Warriwillah, Australia**
330 x 380 mm (13 x 15 in)

Subject four

# Trees

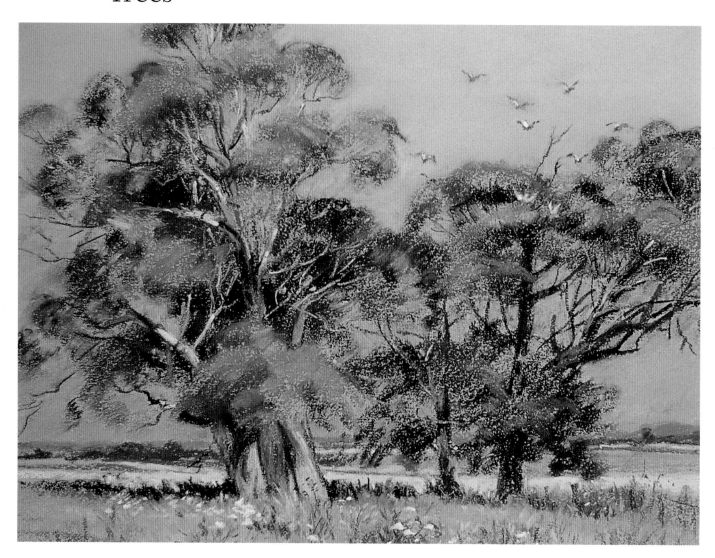

In February 1993 my wife and I flew to Australia. I had been invited to tutor some pastel workshops by friends who run painting holidays at their farm 170 miles north west of Sydney.

Every morning I would get up at sunrise and spend an hour sketching before breakfast. There was an impressive group of eucalyptus trees close to the farm, and I made a careful study of them (see Fig. 9) before embarking on the painting itself. I was fascinated by the way the soft grey-green of the foliage contrasted with the gleaming white bark of the branches.

Colours are so much more intense 'Down Under' and it was refreshing to be able to

**Fig. 9 Sketch of eucalyptus trees**

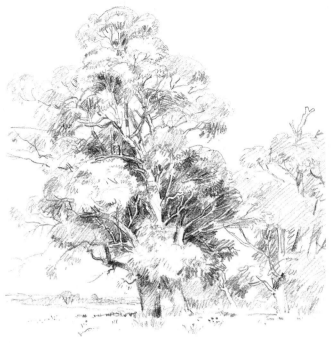

use strong ochres, yellows and siennas in the grasses instead of the greens which are so commonplace in England.

Trees are infinite in their variety and form an integral part of the landscape. They provide dark accents which, like punctuation in an essay, give pattern and variety to the painting.

I have outlined five points for you to consider which may prove helpful when painting trees:

**Silver Birches, Walton Heath, Surrey**

356 x 533 mm (14 x 21 in)

**Sketch of ash tree**

39

**Beeches at Tarr Steps, Exmoor**

356 x 533 mm (14 x 21 in)

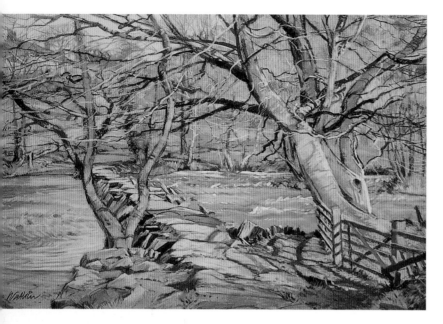

**Giant Sycamore, New Forest**

330 x 305 mm (13 x 12 in)

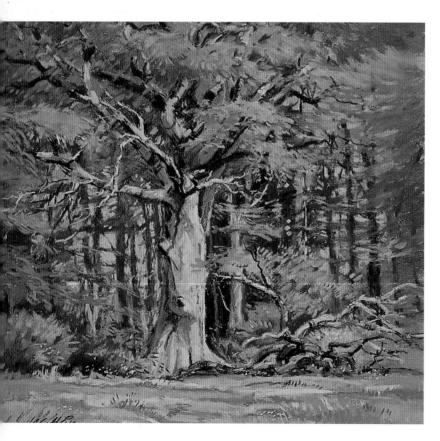

## Shape

Trees are recognizable by their shape, colour and particular characteristics. Choose a tree which catches your eye. Spend time studying and drawing the trunk and the main branches, noting the angle at which these grow and divide to give that tree its particular shape. This exercise is easier in Spring or late Autumn when there are no leaves to get in the way. An example of trunks and branches can be seen in *Beeches at Tarr Steps, Exmoor.*

Placing some of the branches in shadow helps to emphasize those in light and flicking in a few light twigs against some of the darker areas adds to the interest. Notice how cast shadows help to describe form.

In *Giant Sycamore, New Forest*, the branches alternated between light and dark. To accentuate the light trunk I painted the trees in the background with green-greys and blue-greys. The dark shadow to the left of the trunk was cast by the branch above it.

## Foliage Mass

This will differ according to the time of year. In spring the buds are bursting and the brilliance of the colour is often quite startling. In high summer the full foliage sits heavily upon the branches, while in Autumn, when the leaves begin to fall, the colours are often breathtaking. In this painting, *Autumn Walk*, the separate masses of foliage are clearly seen, particularly in

**Autumn Walk near Tadworth, Surrey**

356 x 533 mm (14 x 21 in)

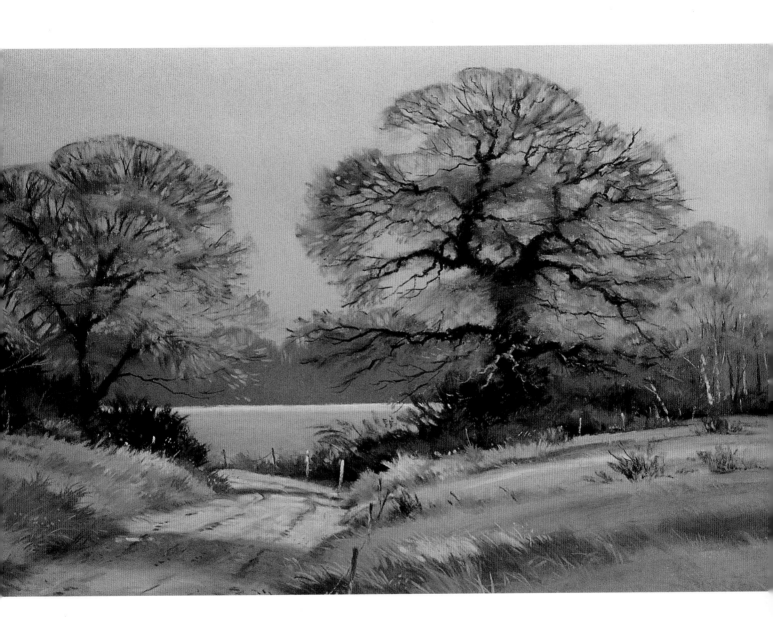

the tree on the left. The more you observe and sketch trees the easier it will be to render them realistically in your paintings.

## Foliage Texture

Each tree has its own individuality and each leaf its shape, but the artist must learn to simplify and suggest this information rather than trying to render every knot in the bark or vein in the leaf. Birches are lightly foliaged, and the sky is clearly visible through their branches (see *Silver Birches on Walton Heath, Surrey*, on page 39). The ash on page 39 is also delicately dressed and requires a light touch, whereas oaks and horse chestnuts fall into the heavyweight class.

41

**Way to the Quantocks, Spring**

356 x 533 mm (14 x 21 in)

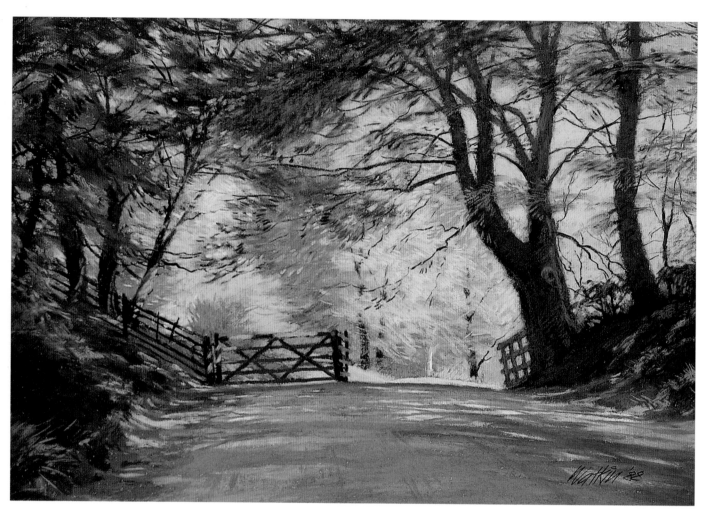

## Light and Shade

Light passing over an object describes its
form. Half close your eyes and note how
the light describes the main foliage masses
of a tree (ash and oak are helpful here).
These separate masses are vaguely lozenge-
shaped, and wrap around the trunk, being
larger on the lower branches and smaller
on the upper. One side of the tree will be
in shadow, but some branches will be
catching the light where the sun finds its
way through gaps in the foliage. Cast
shadows from other branches play across

these here and there, and describe their
form. Look at my painting *Way to the
Quantocks, Spring* which is all about light
and shade. Don't forget that trees cast
shadows on the ground, and these are
usually cooler in tone because they reflect
blue from the sky.

42

**Midday Sun, California**

254 x 356 mm (10 x 14 in)

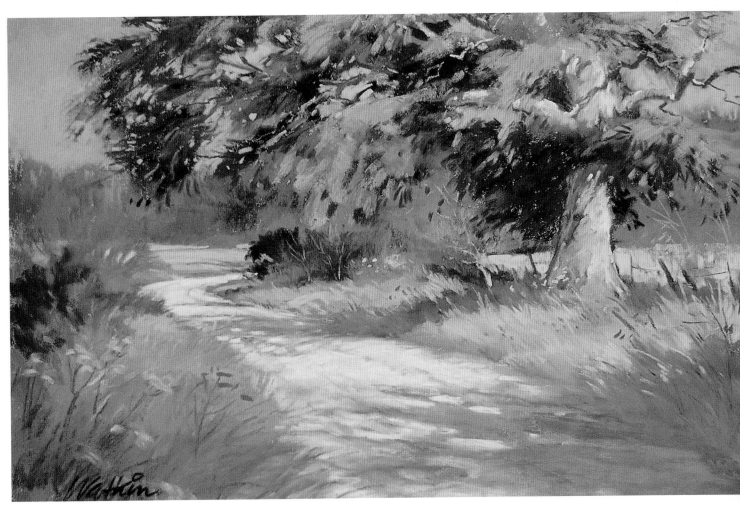

Oak tree near Blue Ball
6.1.92 4pm.

## Reflected light

When the sun is very bright, you will notice
how light from the grass or road is
reflected up onto the underside of foliage
and branches; it also creates a glow on the
shadow side of the trunk. In my painting
*Midday Sun, California* the intense light is
reflected in the lower branches of the tree
on the right. To achieve maximum tonal
contrast in your painting, the value of
your lights should be directly influenced
by the intensity of your darks.

43

# Demonstration: Oak Tree

**Paper:** Canson Mi-Teintes
(No. 343) 160 gsm
**Pastels:** Rowney

## *Stage 1*

With a stick of charcoal I drew in the trunk
and the main branches, taking great care
to portray accurately the skeleton of the
tree and establish the overall shape of
the foliage masses. Using the side of the
charcoal I blocked in the main darks,
while bearing in mind that the light was
coming from top right. This monochrome
provided the tonal framework to the
picture and it was then fixed.

## *Stage 2*

Using the side of a stick of olive green I
blocked in the darks of the foliage and
restated the trunk and some of the
branches with the edge. The middle tones
of the foliage and the grass were then

added with olive green. Coeuruleum was
then dragged quickly over the sky area,
not forgetting the 'sky holes' between the
branches and the foliage.

## *Final stage*

A warmer green, sap green, was added over
some of the dark foliage and the darks
livened up with olive green. The trunk
and main branches looked too grey so
touches of Vandyke brown were used to
warm them. To lend punch to the lightest
areas of foliage and grass I added some
cadmium yellow, using the edge of the
pastel to pick out a few individual leaves
here and there to create interest, in
particular against the dark trunk. I then
dragged some yellow ochre across the sky
to suggest clouds and inserted more 'sky
holes', making sure that they matched
the colour of the sky in that area. The sky
was then smoothed, while at the same
time I darkened it at the top with indigo.

I picked out one or two branches catching the sunshine with olive green, and added a few dark leaves to some of the minor branches. Finally I described the broken branch lying in the grass with light and dark olive green and strengthened the shadow under the tree.

45

**Passing Light near Nettlecombe, Somerset**
356 x 533 mm (14 x 21 in)

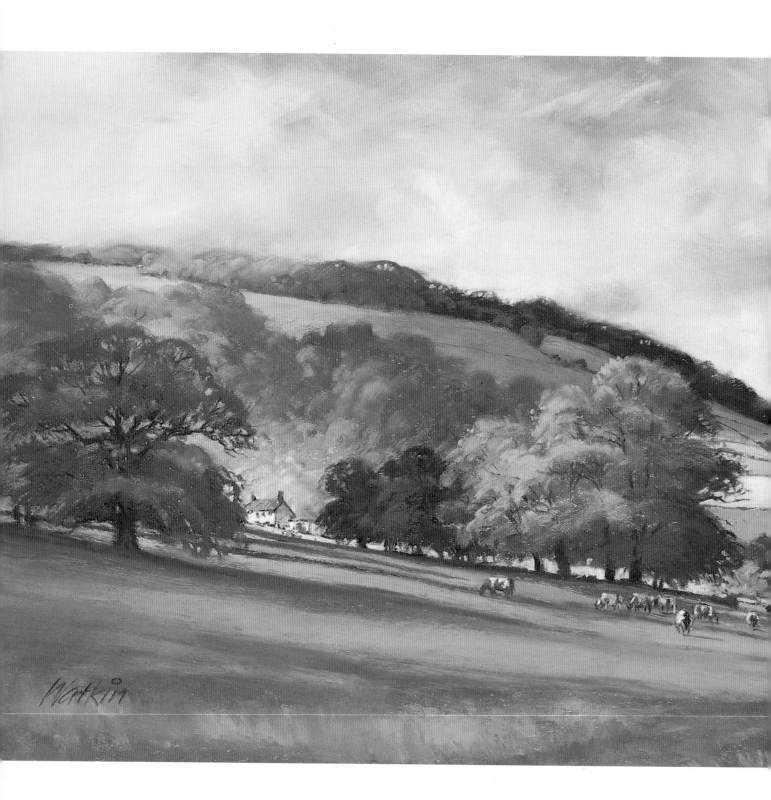

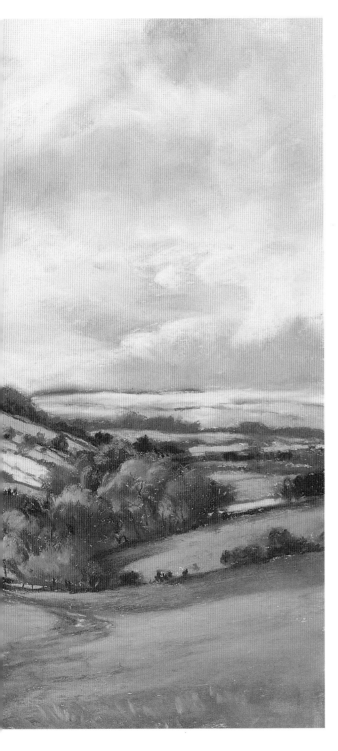

## Wooded Hillsides

The distant landscape is often punctuated by areas of woodland, which are darker in tone than the surrounding fields. Ignore all the tree trunks and detail and simplify what you see into two main tones. Lay in the whole area with the dark tone first, and then drag the light over it in one or two areas to suggest passing light.

As you come forward into the middle distance, more definition is required. Follow the approach outlined above, but when indicating the light areas on the tops of the trees describe the form more accurately and touch in a few light trunks where the sun is catching them. You may need to blend these statements with your fingertips to make sure everything sits back properly.

These points are illustrated in *Passing Light near Nettlecombe, Somerset.* Only the trees catching the autumn sunshine in the middle distance are described in any detail, using contrasting tones of burnt sienna, Naples yellow, Vandyke brown and purple-grey. The trees on the hillside are quite simply stated – the oak in shadow on the left is almost a silhouette and helps to emphasize the distance between it and the cottage. The tonal arrangement of this painting is fairly complex and I prepared three sketches before I felt the balance looked right.

47

**The Tall Chimney, Bicknoller, Somerset**
356 x 533 mm (14 x 21 in)

Subject five

# Buildings

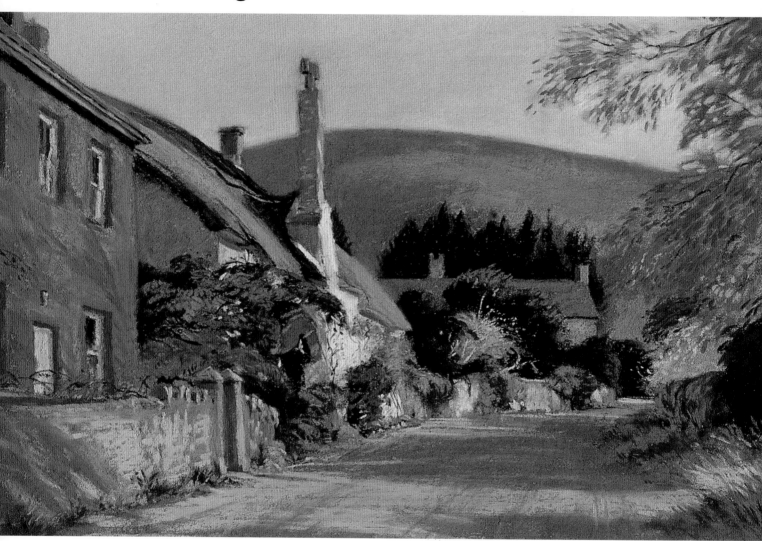

Although each of us need to express our individuality in painting, there are certain principles which must be understood if we are to be convincing.

## The Rudiments of Perspective

Imagine you are standing in the middle of a railway track (don't take this too literally). The lines in the distance appear to converge to a vanishing point on the horizon. What's more, the sleepers have increasingly smaller gaps between them the further away they go.

Now imagine you are sitting on a beach looking out to sea. Where the sea meets the sky is called the horizon line, or eye level. Stand up and the horizon rises accordingly.

**Fig.10 Two views of the same subject from different levels**

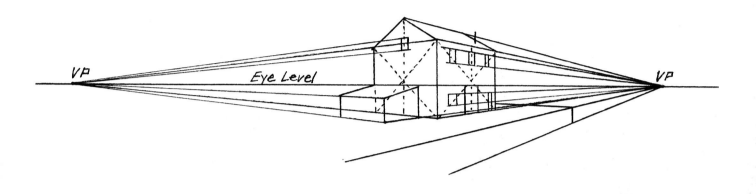

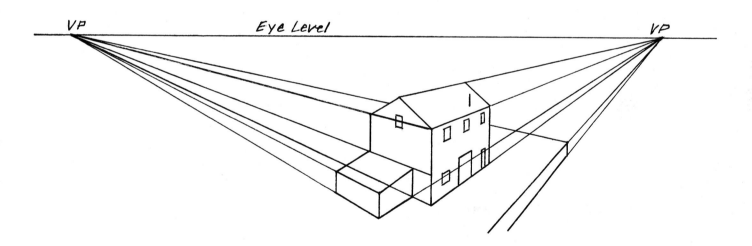

Let us see what happens when we apply these principles to a simple warehouse scene (see Fig.10). Imagine you are looking out to sea at the horizon or eye level. Note where that line cuts through the building on the jetty. On the right facing wall, you will see that all the lines above the eye level – the gutter, windows and ridge of the roof – run down from left to right to a vanishing point on the horizon line, and lines through windows and doors – and where the building meets the ground – run up to the same vanishing point.

49

**Dedham High Street, Essex**

356 x 533 mm (14 x 21 in)

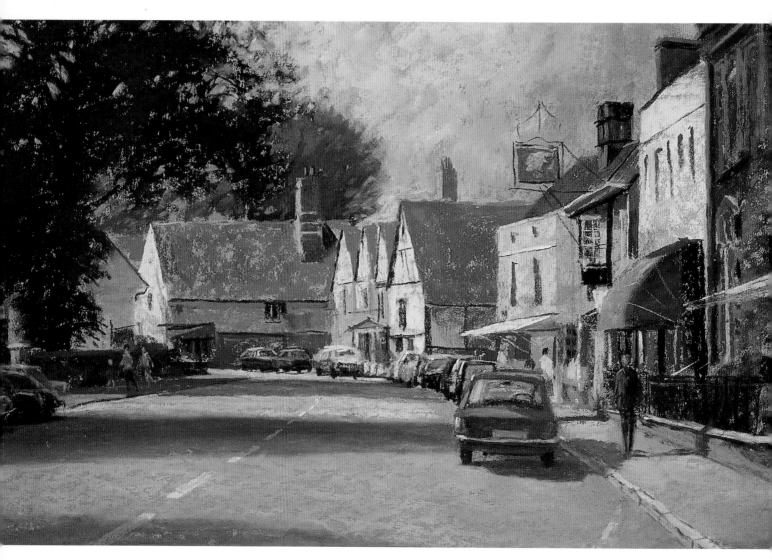

In my painting *Dedham High Street, Essex*, the heads of the pedestrians are parallel to the bottom of the picture. As the road was level and I was standing, those heads told me where my eye level was. All the lines above the heads are running down from top right to bottom left, whereas the wheels of the cars, kerb, railings and wall are running upwards.

Brick-built buildings are always a great help when it comes to establishing the eye level, because you only have to find

a horizontal running through a coarse of bricks spanning two sides of the building. You can then indicate it lightly on your drawing as a reminder. As you add the features of the house you will know that any line above the eye level will run down, and lines below it will run up.

## Foreshortening

Windows further away from you will appear closer together and narrower. A centrally placed door will appear off centre, with

## Cast shadows

the largest gap between the door and the end of the building nearest to you. If you are uncertain where to place a central door or feature in a wall which is at an angle to your line of vision, lightly draw a couple of diagonal lines between the four corners. Where they cross is the true centre, allowing for foreshortening. You can also use this method to establish the apex of a roof on an end gable.

When a building or chimney interrupts the passage of sunlight it casts a shadow on the ground or adjacent roof. As a general rule of thumb, and because cast shadows receive very little reflected light, this is usually a tone darker than the shadow side of the house or chimney. Shadows are also subject to perspective and are dictated by the angle of the sun. At noon, when the sun is at its highest, shadows are short whereas in the morning or early evening they can be quite long.

## Light and shade

When rendering tones on a building, try to restrict them to three – light, half tone and dark. This simplifies things considerably and provides a degree of unity and solidity to the forms. The lightest tones occur on planes (walls or roofs) directly facing the light source; the half tones on planes at an angle to the light; and the darks on planes that receive no direct light.

**Yard Farm Across the Meadows**

330 x 432 mm (13 x 17 in)

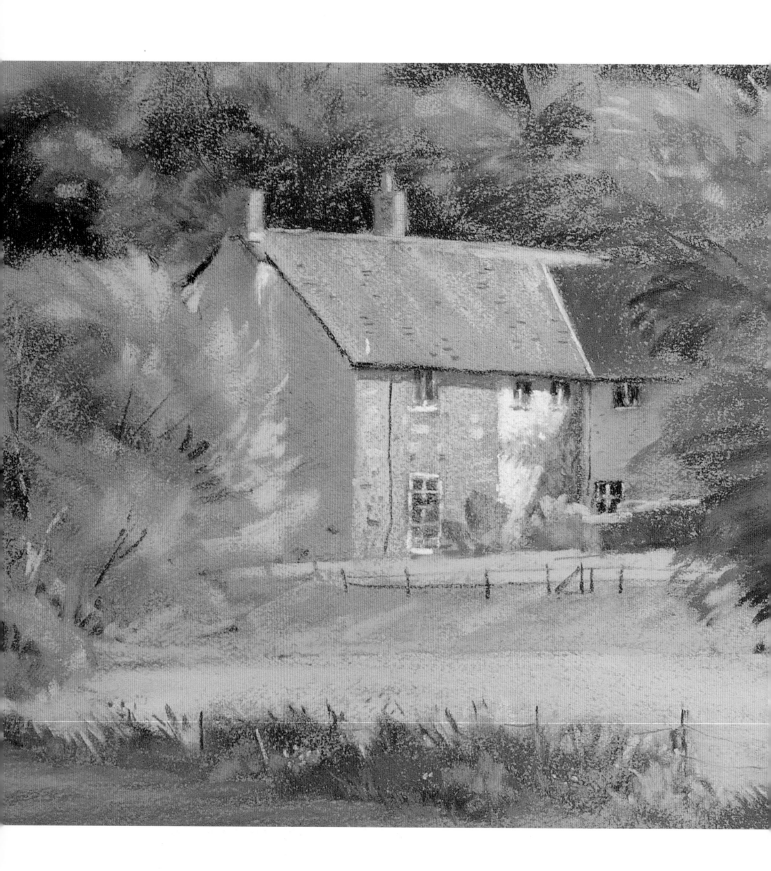

## Reflected light

When light strikes a surface it is reflected
back into a shadow area. This is known as
reflected light. The smoother and lighter
the surface, the stronger and warmer the
reflected light. In the painting of my home
in Somerset, *Yard Farm Across the Meadows*,
the wall to the right of the angle is in
shadow, but it glows with light reflected
from the lighter, rendered wall on the left.
Notice how much darker and cooler the
cast shadow is across this wall. The gable
end is in shadow but appears darker and
cooler because it is reflecting cool notes
from the sky.

## Texture

Try to convey the different textures of
materials – stone, brick, rendering, slate,
glass and so on – without too much detail.
Often we see paintings where every brick
and stone is carefully described which
looks very fussy. Roofs can be very
interesting: the shine of smooth slate,
particularly when wet, the warmth and
texture of thatch or weathered tiles, all
need to be considered if the character of
the building is to be accurately portrayed.

Having established these principles firmly
in your mind, be positive. Spend time on
your drawing until you are happy with
your perspective, then block in the darks
followed by your middle tones and lights.
If the building concerned is the focal point
of a group, choose a time of day when it
is catching the light, thus emphasizing its
importance in the context of the painting.

53

# Demonstration: Village Scene

**Paper:** Hermes P400 glasspaper 381 x 559 mm (22 x 15 in)
**Pastels:** Rowney, Schmincke and Unison

**Photograph of Broadhembury**

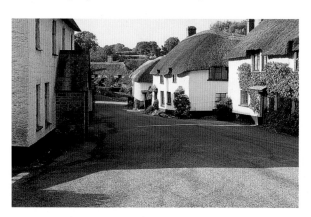

## Stage 1

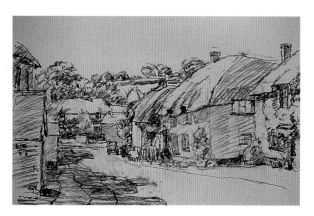

With a 4B pencil I drew in the cottages making sure that the left-hand end of the main cottage was near the centre. My eye level coincided with the eaves of the cottage beyond the bridge; you will notice that the ground floor window sills of the main cottage are all running up from right to left, whereas the dark line painted on the walls follows the angle of the road, indicating that it is going

downhill. I blocked in all the shadows and established the general tones of the picture, added the small Citroen and the figures, and fixed the drawing.

## Stage 2

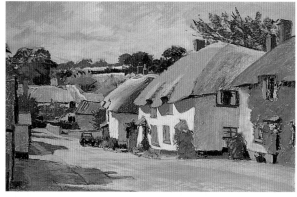

Starting with the focal point I used raw umber and autumn brown for the thatches and pale yellow ochre for the sunny walls. The glow in the shadow on the wall of the main cottage was caused by reflected light from the facing wall to its right. I blocked in all the greenery with dark sap green and olive green, ignoring the lights in these areas. To aid recession I painted the trees on the horizon with blue-grey and purple-grey. For the cottages on the left I used mixtures of autumn brown, cool grey, raw umber and sepia with similar mixes in their shadows. I added burnt umber and burnt sienna to the smaller thatch and barn at the end of the road, and shaped up the car with some madder brown before blocking in the general colour of the cottage windows with warm greys. Finally I put in the sky using pale

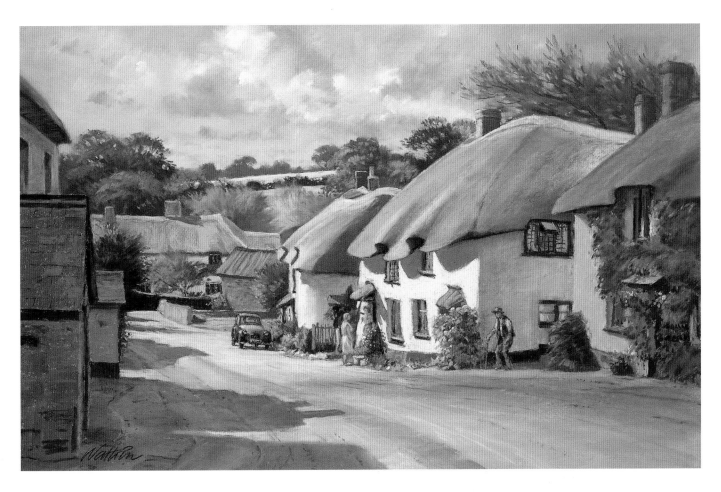

indigo, coeuruleum, purple-grey and
yellow ochre.

## Final stage

I re-worked the sky to echo the diagonal
of the road, introducing more mid tone
purple-grey and cobalt blue and lightening
it on the left with pale yellow ochre.
Next came the trees on the horizon which
I lightened with touches of Unison blue-
violet. I added more pale lemon yellow to
the sunlit corn field and using a variety
of light and mid tone greens I finished off
all the trees and shrubs. The thatches were
then tidied up, particularly the shapes
around the window apertures, followed

by the deep shadows on the wall. These
were surprisingly warm, no-doubt due
to reflected light from the road, and to
underline the contrast I added more pale
yellow ochre to the walls and lightened
the road in front of the cottage.

The little Citroen and the figures needed
some attention and the flower beds and
hanging baskets more colour. After adding
a few cooler colours to the shadows across
the road and a few lines and rough patches
in the foreground I retired to the Drew
Arms. It was a very hot day!

55

**Early Morning on the Stour, Suffolk**
356 x 533 mm (14 x 21 in)

Subject six

# Water

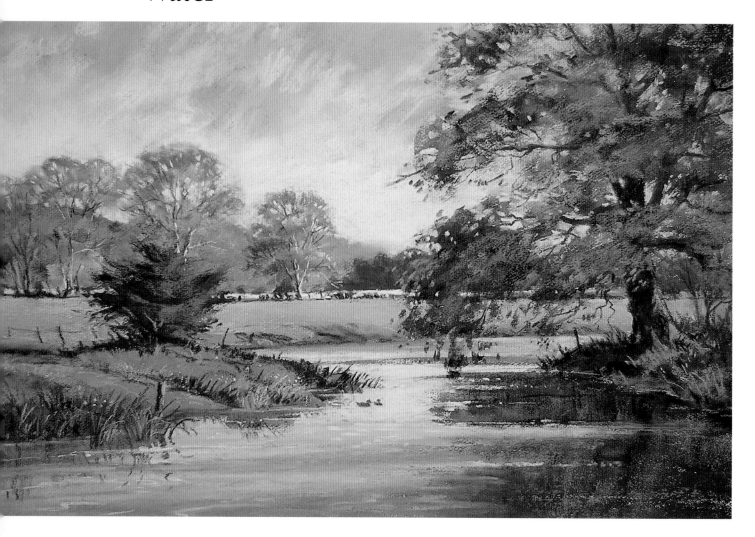

For many of you, family holidays will provide a much sought-after opportunity for painting and sketching. A wet week in Wales found me sitting on some rocks under a large umbrella, in the middle of a wide stream above Harlech, painting the rushing torrent. There was a picnic area on the far bank and the tourists considered me quite an attraction!

56

**Quiet Mooring, Derek's Pond**

356 x 533 mm (14 x 21 in)

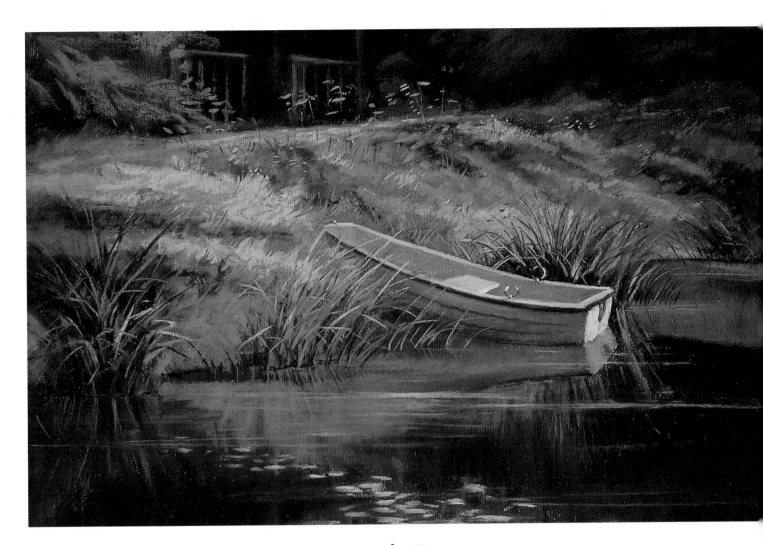

## Smooth Water

*Early Morning on the Stour, Suffolk* was painted early one September morning while my family were still in their beds. The air was cool and still, with little or no breeze to disturb the water which acted as a mirror to the sky, bank and overhanging trees. The glow in the sky was reflected in the water, as were the lovely deep shadows under the tree on the right-hand bank.

57

**Fig. 11 Reflections**

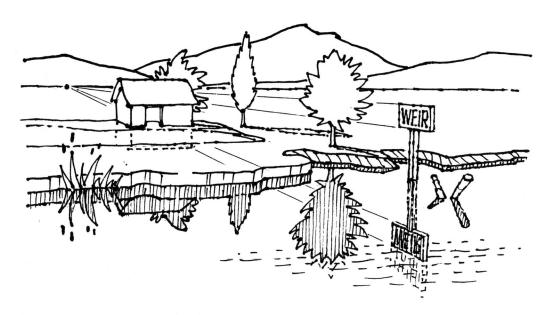

## Reflections

The colours of the sky are reflected in the water. Anything which is at the water's edge is reflected exactly as in a mirror image, but remember that objects which are further away from the bank may only partially appear in the surface of the water or not at all (see Fig.11). As a general rule of thumb, reflections of dark objects appear slightly lighter and light objects darker. This is evident in *Quiet Mooring* (see page 57), where the light stern of the dinghy is considerably darker in the reflection. Because the bank slopes away from the water's edge only a third of it is reflected in the water and the reflected image is both darker and softer. To create a feeling of depth reflections should be portrayed using vertical strokes with the occasional horizontal, usually the sky colour, to indicate the surface.

Because the reeds (a) and vertical bank (b) are at the water's edge they have a 'mirrored image' in the water while the reflection of the sloping bank (c) is reduced to aproximately one-third due to its angle. The only part of the barn (d) to be visible in the water is its roof. This is determined by measuring from the top of the roof to an imaginary point below the raised ground, where it is estimated the surface of the water or 'mirror' would lie (see dotted line). From here the image is reversed. Being further back, tree (e), though taller than tree (f), shows less in the water and the mountain (g) not at all. Perspective affects angles. The angle of the weir sign (h) is much more pronounced in its reflection because it shares the same vanishing point; we also see the underside of the sign in the water. Posts leaning away (i) have a shallower, lighter reflection than those leaning towards the viewer (j). Reflections are deepened by ripples on the water's surface (k).

**The River Barle, Exmoor in Spring**

356 x 533 mm (14 x 21 in)

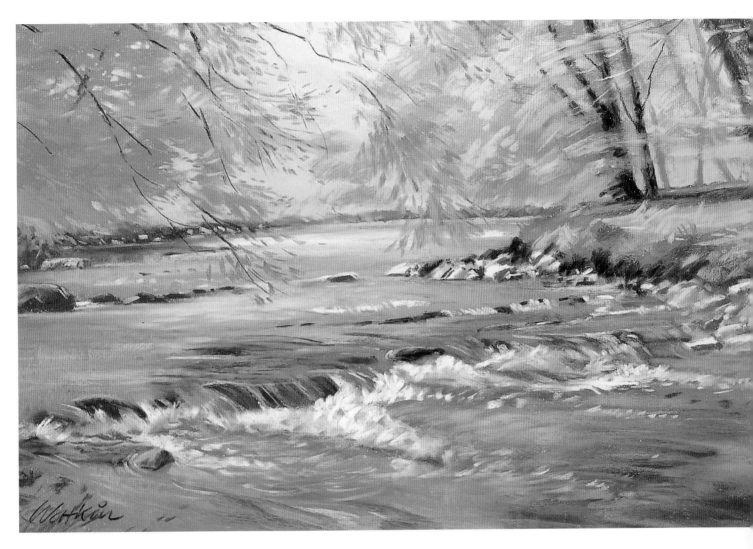

## River Perspective

Rivers are subject to the same principles of perspective as buildings and roads. Nothing looks worse than a river flowing uphill – and I've seen plenty. Even when the river takes a zig-zag course, you still have to apply the rules of lines converging to vanishing points on the horizon line.

## Fast-moving Water

Now look at my painting *River Barle, Exmoor in Spring*. Unlike the Stour, the Barle on Exmoor is a shallow, fast-moving river with occasional deep pools, rocks and overhanging trees creating dark shadows under the banks. Because the surface is broken into lots of little facets, reflections are not evident, except in some of the quieter areas nearer the bank where the water is flowing more slowly. In one or two places I have suggested the colour of the shallow bottom where it is caught by the sun. This warmer, lighter colour contrasts nicely with the darker areas.

59

**Through the Watermeadows**

254 x 356 mm (10 x 14 in)

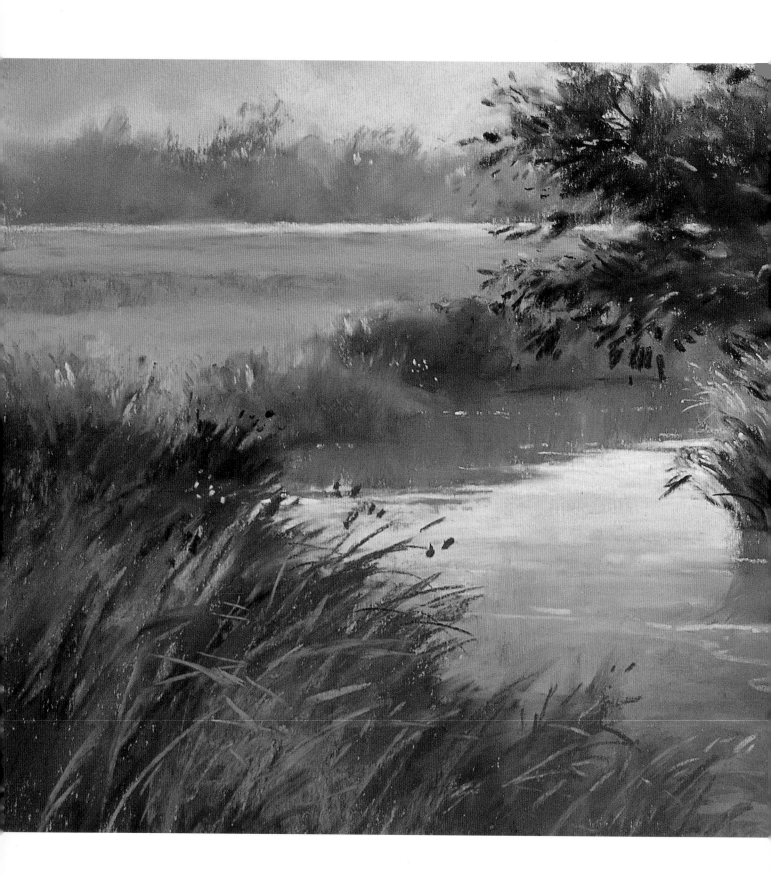

Broken water is created by fast-flowing water coursing freely down a river and bouncing off rocks, boulders and sometimes debris. These obstacles break up the surface into foam, spray and swirling eddies. This type of water can be very dramatic and in its wildest form provides what is known as 'white water'.

When painting broken water vary your pastel strokes by making them follow the form, particularly where the near-vertical elements are concerned, and be careful not to overdo the whites. Decide where you want maximum impact, possibly where the sun shines through a gap in the trees lighting up the water in one area, and play down the surrounding areas slightly. Be sparing with your highlights and flecks of spray. Many a painting has been spoiled by overdoing these final details.

## Dykes and Streams

Many years ago, I painted a little stream bordered by reeds running through watermeadows near Lewes in Sussex. My wife thought it was a little gem, and I must say I was pleased with it. I used the original sketch of *Through the Watermeadows* for my pastel version. I used a limited palette of autumn browns, olive greens and blue greys, with lighter accents of yellow ochre and purple grey. The focal point of this painting, the sky reflected in the water, was emphasized by placing the main contrasts in that area. Note the strong colour in the reflection of the far bank.

61

**Towards East Lynch Farm, Selworthy**
254 x 356 mm (10 x 14 in)

# The Three Planes

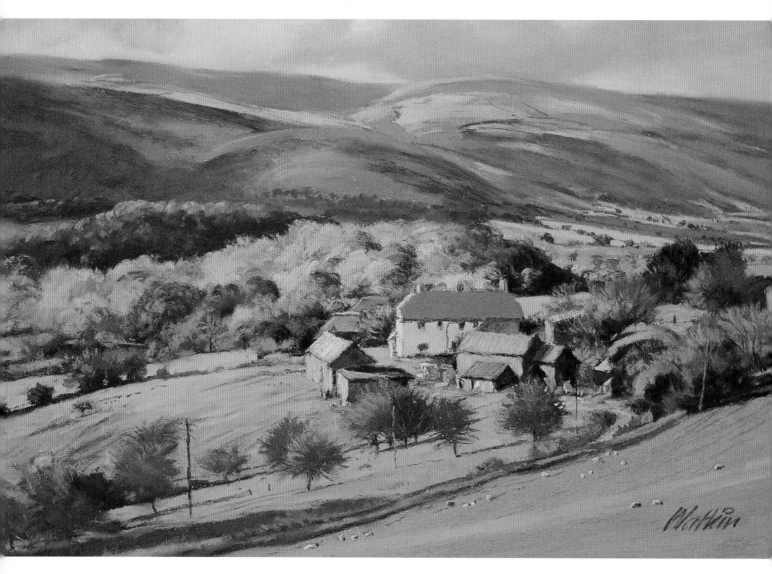

In order to give our paintings depth, we must divide them into three planes: foreground, middle distance and background. These three key areas are evident in my painting *Towards East Lynch Farm, Selworthy*. On this occasion, the focal point is in the middle distance – the farm buildings in front of the brightly lit autumn trees.

The lane in the foreground leads the eye towards the farm with a few sheep for added interest, and the distant hills of Exmoor provide a dramatic background.

**The River Exe, near Dulverton**

356 x 533 mm (14 x 21 in)

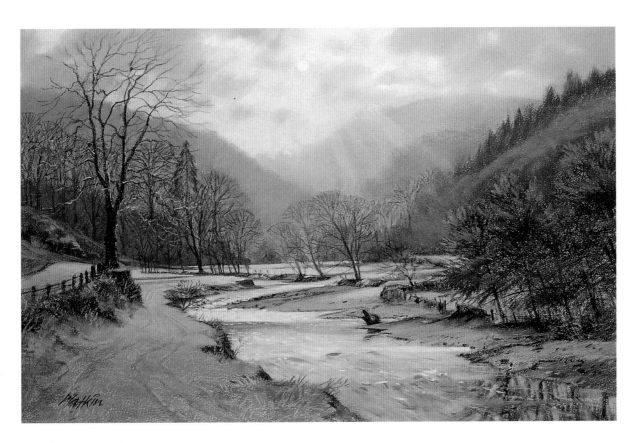

# Background

The background is, as it sounds, the backdrop to your scene. As such it should never be intrusive. It is important to make sure that the background does not dominate the picture. In order to do this everything must be subdued by exaggerating the blues and greys. Occasionally the distant hills will appear very blue while at other times, when the air is clearer, they will look less so. In certain conditions hills will merge with the sky, which you can see in *The River Exe, near Dulverton*. I depicted the distant hills and trees in three tones of cool and blue-grey which enhanced the feeling of recession. I used the same pale warm grey and cool grey for the central, distant hill and the clouds, and heightened the sense of atmosphere by including some rays from the sun which is just visible through the haze. Over half of the picture is background and the cool colours contrast nicely with the warmer, brighter tones of the valley. We call this feeling of distance 'recession' or 'aerial perspective'. To emphasize the effect I advise my students to smooth both background and skies. If you are working on glasspaper make sure you have plenty of pastel on the surface, otherwise you will find that you end up with sore fingers.

63

**Fig. 12 Using cloud shadows to emphasize the centre of interest**

a

b

## Middle Distance

As we move forward, colours become slightly more assertive and edges a little sharper. Not surprisingly it is usual to place our focal point in the middle distance or, to use an analogy of the theatre, 'centre stage'. This can be emphasized by clever use of light. Depending on the subject matter it is important to establish either a light area against a darker background, or (as in a back-lit subject) a dark middle ground against the light area beyond which produces interesting bands of lights and darks. This approach was frequently employed by that great British painter, Edward Seago (1910-74) in his Norfolk landscapes. There is more texture in this area on grasses, tracks and roofs so use your pastels inventively, laying colour over colour with little merging.

## Foreground

The foreground should be kept relatively simple if the main subject is in the middle distance. It should also act as a lead-in to the picture. You can reserve your strongest colour for this area, but grasses, wild flowers and brambles should be simplified, except on the rare occasion when the focal point is right at the front of the picture, in which case the middle distance will have to be subdued.

## Cloud Shadows

Shadows from clouds can be utilised to break up a picture into three main areas. I generally place the foreground and background in shadow, leaving the middle distance, and focal point, in light (see Fig. 12a) which helps to hold the bottom of the painting. An alternative is shown in Fig. 12b. More often than not, it is the location of the main interest that determines the main shadow areas.

Another point worth mentioning concerns the depth of the three planes. Equidistant spacing tends to be repetitive, so vary the spacing as much as possible. When painting mountain subjects you may find the background area is deeper than the other two put together.

# Demonstration: Porlock Bay

In August and early September the hills of
   Exmoor are covered with heather, the
   reddish purple contrasting with the pale
   yellow seed heads of the long grasses. I
   chose the view from Dunkery Hill looking
   towards Porlock Bay and the Welsh coast
   for my painting, and made two sketches,
   one from each side of the road which runs
   down the hill, before deciding on the final
   composition.

**Paper:** Hermes P400 glasspaper
381 x 559 mm (15 x 22 in)
**Pastels:** Rowney

## *Stage 1*

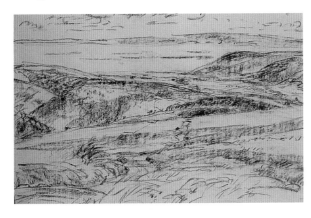

The tonal lay-in established the composition
   and the position of the main darks.
   The three planes were very evident: the
   background formed by Hurlstone Point
   on the right and the Welsh coast; the
   middle distance occupied by the tree-
   covered hill (Webber's Post); and the
   foreground with the road leading the
   eye towards the centre of the picture.

## *Stage 2*

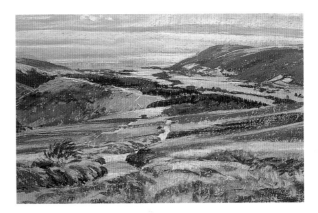

Starting with the cool colours in the
   background, the sky, coast and sea, I
   then added the purple-greys and green-
   greys of Hurlstone Point and grass green
   and pale viridian for the fields in the
   valley. Moving forwards to the conifers in
   the middle distance I used dark tones of
   terre verte and green-grey with olive green
   for the grass areas and pale Vandyke brown
   for the tracks. The foreground colours
   were much warmer – sap green, olive
   green and autumn brown were used for
   the grass, and purple brown, red-grey
   and reddish-purple for the heather.

## *Stage 3*

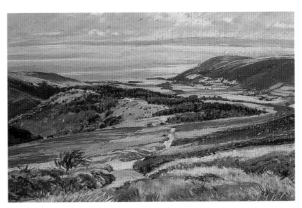

65

Returning to the background, shadows were added to the wooded slopes on the distant hill and continued across the valley with purple-grey and green-grey. At the same time I introduced some warmer accents for cornfields. Moving forward into the middle ground I lightened the pine woods and added individual trees on the slopes and along the track. The foreground area needed modifying slightly with the same warmer tints of autumn brown and yellow ochre. The road looked too cool so I warmed it with pale Vandyke brown and strengthened the shadow across it.

### Final stage

To aid recession I started by rubbing in the sky. Next, using the corner of a pastel, I suggested some cliffs on the Welsh shore and added a sliver of light on the sea before smoothing the shadows on the water. Some warm fields and sunlight were introduced to the distant hillside. Apart from defining the left-hand slope of the central wooded hill, the middle distance needed no further attention. I simplified the cloud shadows on the heather-clad slopes to the right and introduced much more light to the heather and the grasses in the foreground.

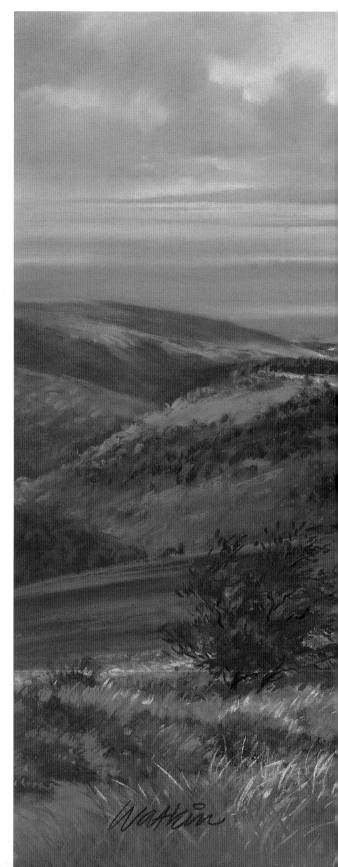

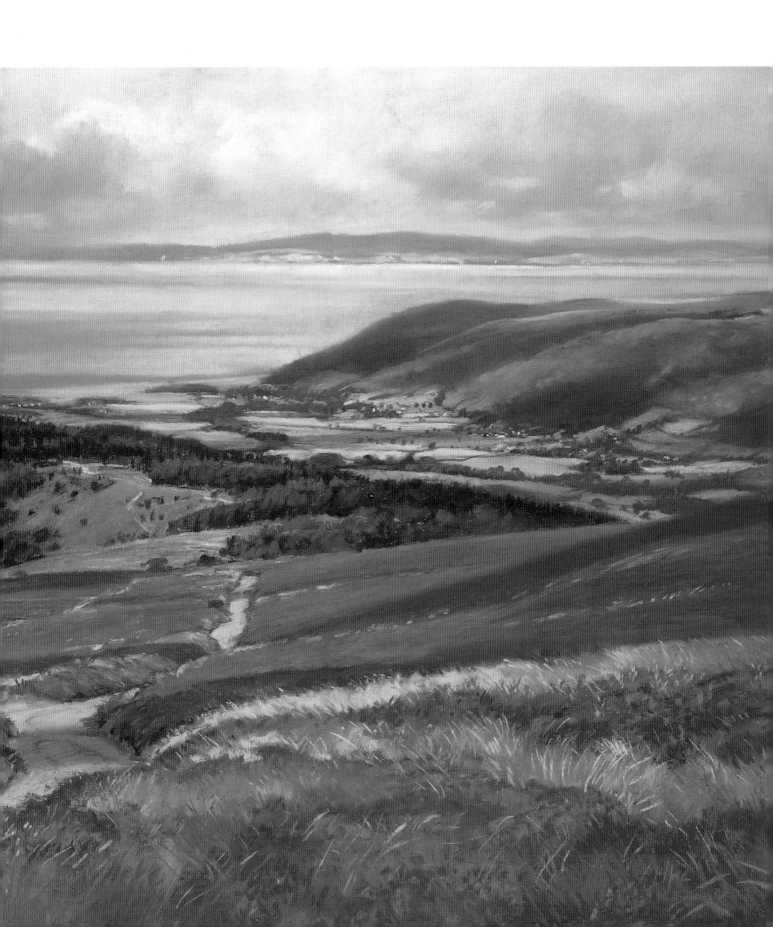

**Late Afternoon, Bicknoller**
190 x 241 mm (7½ x 9½ in)

Subject eight

# Atmosphere

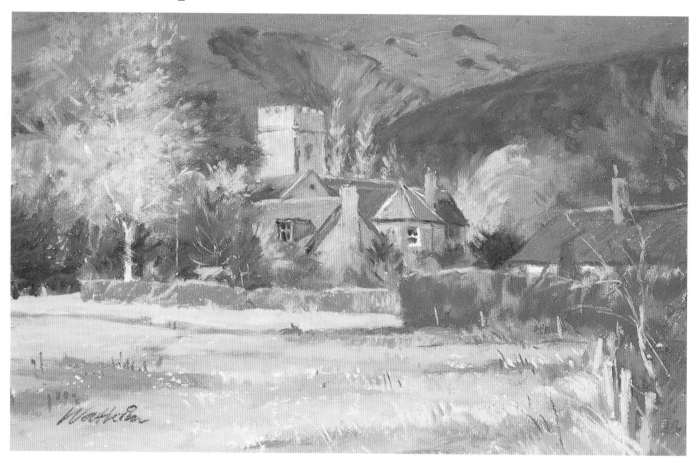

If there is one ingredient which will lift your paintings onto a higher plane it is mood, or atmosphere. Whether you are painting a thunderstorm, a misty morning, a glorious sunset or waves crashing down onto wet rocks, provided the prevailing mood of the painting is captured, the sins . of shaky perspective and weak drawing can often be forgiven.

Collins' Concise English Dictionary defines atmosphere as 'the prevailing tone or mood of a novel, symphony, painting'. I think most artists would agree that atmosphere is the effect of the elements transforming the landscape into a wide diversity of moods. We sometimes refer to the day as 'heavy', which means there is considerable moisture in the air. This reduces local colour and introduces bluish overtones which are particularly strong in the distance. I often remind my students that there is a blue veil suspended between them and their subject. Colours change quite dramatically towards evening. Distant hills and fields take on shades of purple, violet and orange-pink while skies range from lemon yellow to pale orange,

**Passing Light, Crossways Farm, Surrey**

356 x 533 mm (14 x 21 in)

through cooler notes of coeuruleum, Prussian blue and indigo.

Introducing atmosphere into your work requires simply stated tones, soft edges and minimal detail, the whole bound together by the quality of the light. The effect of passing light is exciting but we must be quick about it – be sure to have your sketchbook to hand or you could be disappointed. Ideal conditions are more prevalent in Autumn or Winter when the atmosphere is sharper. If there are a few clouds about they can create some very interesting shadows on the landscape.

Many years ago in Surrey I used to paint with an old chum of mine whenever business – or the weather – permitted. Although in those early days his perspective (like his coffee) was not too hot, Doug had the most wonderful knack of creating atmosphere in the most unlikely subject matter. *Passing Light, Crossways Farm, Surrey*, reminds me of those happy times and underlines my point about the use of light and shade to create atmosphere.

69

**Moorings, Emsworth Harbour, Hampshire**
356 x 533 mm (14 x 21 in)

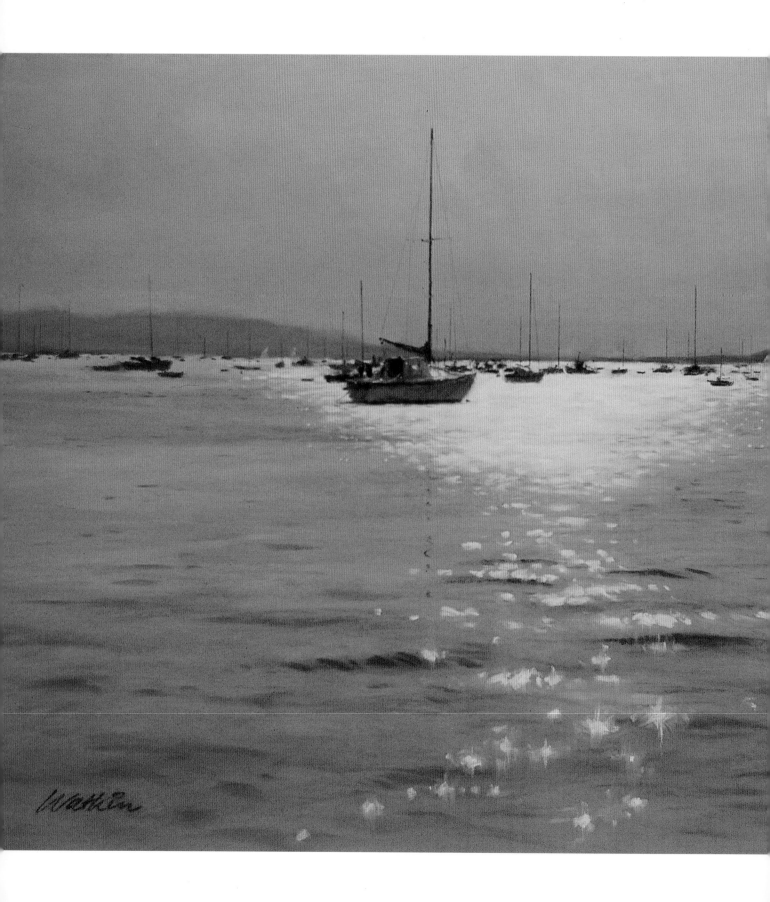

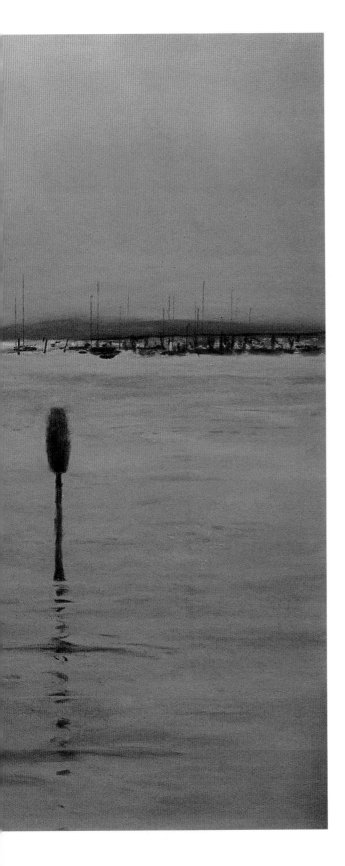

The gleam of sunlight (or moonlight) on water is always attractive and stirs the romantic in us. *Moorings, Emsworth Harbour, Hampshire* demanded the use of a very restricted palette with the sky and water basically the same tone and colour. Cooler notes were supplied by the boats at anchor and the distant coastline. The big challenge in a painting of this nature is getting the tonal values right. To make glints in the water look convincing it is necessary to add a few blobs of white, soften the edges and then add a crisp verticle line with a sharpened pastel. Stars on a Christmas card are produced this way!

**After Rain, Monksilver, Somerset**
356 x 533 mm (14 x 21 in)

One of my most successful paintings portraying a very different aspect of atmosphere is my painting *After Rain, Monksilver, Somerset*. Here a shaft of sunlight breaks through the rain clouds producing dazzling reflections in the soaking road. The gleaming telephone wires help to lead the eye into the picture. If you find details like this difficult to draw in accurately, an old trick learnt from my days as a commercial artist might prove useful. Lay a sheet of tracing paper over the painting and draw in the wires between the the posts, making sure that you get the rhythms right and the spacing equal between groups of wires. Then rub white chalk, or pastel, over the lines on the reverse side of the tracing paper. Place the paper in position on the painting and scribe through with a ball-point pen or hard pencil. Remove the tracing paper and there are your lines.

72

**Evening Light near Dedham, Essex**

356 x 533 mm (14 x 21 in)

If you want to strengthen them here and there, as I did, sharpen a stick of white pastel to a chisel point and touch them in lightly using short, broken strokes.

Some years ago I made some sketches of trees in the watermeadows near Dedham Hall and then later worked them up into an oil painting. My pastel version, *Evening Light near Dedham, Essex*, was an exercise in atmosphere based on two of these sketches. It gave me the opportunity to exploit a wide range of pure colours, which I applied with little or no merging, using fixative between the layers. To draw the eye into the picture I used my lightest yellow-green for the distant field. The long shadows provided the foreground interest.

73

# Demonstration: Early Morning on the Stour

**Paper:** Canson Mi-Teintes (No. 431)
**Pastels:** Rowney

## Stage 1

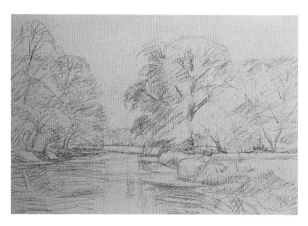

The watery sun reflecting on the water balanced by the big oak formed the cornerstone of the composition. With a stick of charcoal I lightly indicated the position of the main shapes, placing the main horizontal where the distant bank of trees met the water-meadows. Great care was taken with the perspective of the river. Notice how much flatter the line of the left-hand bank is, compared with the right. Once the main shapes were stated I drew in trunks, branches, shadows, reeds and reflections, and using the side of the charcoal blocked in some tone to establish values. The paper was left clear where the light from the sun was reflected in the water. This was my focal point. I then fixed the drawing to prevent the charcoal sullying the pastel.

## Stage 2

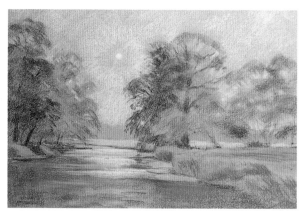

First I established the lights using pale purple-grey, red-grey and warm-grey to lay in the sky, the watery sun and the main light on the water. This was a good time to break a few lights into the foliage to prevent the trees looking too solid. I used olive green for the distant watermeadows and autumn brown and sap green for light on the left bank and the reeds to the right.

The distant trees were put back with blue-grey while the foliage of the main trees was blocked in with a mixture of green-greys. The tree trunks were stated with the same dark green, adding terre-verte to cool them here and there. Olive green was perfect for the water, with sap green for the weed on the surface. For the reeds on the right-hand bank I used a mixture of mid olive green and autumn brown.

## Stage 3

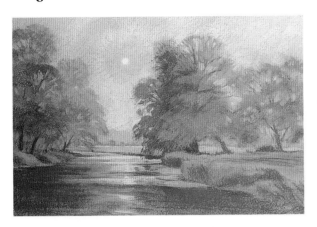

Now was the time for me to assess tone
values and develop each aspect of the
painting. Starting with the sky I darkened
it slightly with cool grey at the top,
warming and lightening it with tints of
red-grey and purple-grey, with a hint of
yellow ochre near the horizon. The
background was finished by adding some
small trees using a dark cool grey. To aid
recession I merged the sky and
background with my fingers. The tree
overhanging the water on the left was then
put back with a mixture of green-grey and
cool grey. The small tree behind the main
oak was still too dominant and was
lightened by adding more blue-grey and
green-grey. This restored the balance. I
then developed the two trees to the right
with a hint of autumn brown. To achieve
more depth in the reflections in the water
I added dark green-grey.

## Final stage

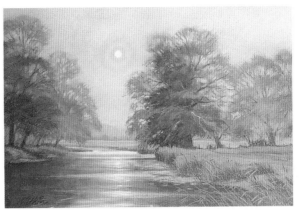

To bring the picture to life, I spent time
describing the lovely oak on the right.
It looked better every time I added more
darks prior to dragging a few lighter tones
of green-grey across it to suggest the
foliage. I added one or two light branches
for contrast and darkened some of the
others. More sky colour was added into
the trees and some fine branches were
indicated. Using the edge of the pastel
I flicked some accents into the reeds using
autumn brown and sap green. Returning
to the water I added light tones of cool
grey and yellow ochre plus a few
highlights in white (cream shade) for
the reflection of the sun, softening some
of these statements with my fingers. I
re-stated the halo around the sun, and
lightened the weed on the water and the
reeds in the foreground. Finally, I added
some wild flowers among the reeds to
complete the painting.

75

Subject nine

# Winter

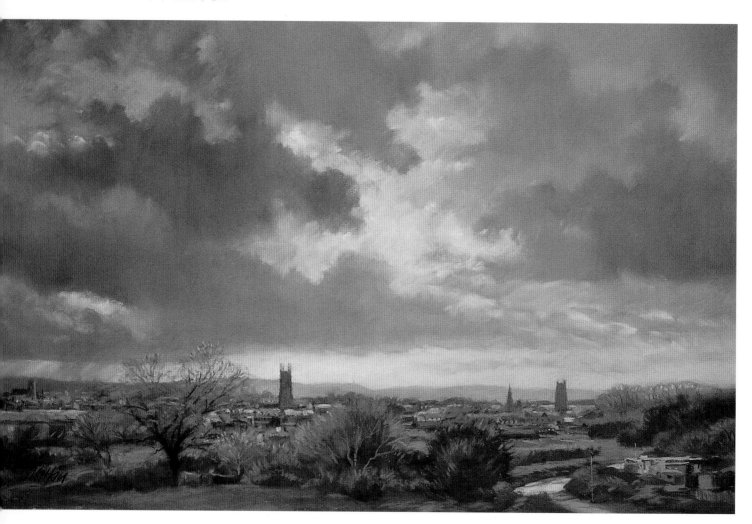

Once into December and January, when
  branches are bare and trees stand starkly
  against the wintry sky, we are into a
  range of warm and cool greys. The
  anatomy of the tree laid bare enables us
  to appreciate more fully the variety of
  pattern and shape. The fine twigs and
  branches silhouetted against the sky
  produce a warm haze of colour, and
  sunlight catching the trunks produces
  some sparkling accents.

Try using a limited palette by removing
all the greens from your box and painting
a winter landscape using yellows, browns,
ochres, red-greys, purple-greys and blue-
greys (see *Evening Skyline, Taunton,
Somerset*, above). The muted colours create
a harmony sometimes lacking in high
summer and the whole painting is unified
by echoing colours of the landscape in
the sky.

**Tadworth Mill in Winter**

356 x 533 mm (14 x 21 in)

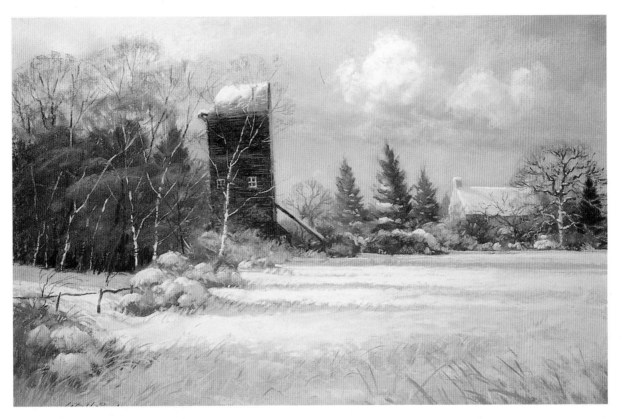

In England, if you wake up to find a white world outside your window, jump into your wellies and get out there fast! It could be gone by lunch time. Though some of you may be reluctant to forsake the warmth of your home for the near zero temperatures outside, when the sun does come through you will be hard put to find more stimulating subject matter.

The range of colours in the shadows is legion: pinks, blues, purples, violets. They provide a wonderful foil to the creamy brightness of the snow in sunlight. Trees, bushes and hedges provide the dark contrasts of purple-brown, warm grey,

burnt umber, and burnt sienna and act like punctuation marks in prose. Subtle cloud shadows enhance some of the darker passages of woods and copses.

There's nothing like a spot of nostalgia if you want to catch the imagination of the viewer. Come to think of it, my painting of *Tadworth Mill in Winter*, on the edge of Walton Heath, Surrey (see above) would make an attractive Christmas card and for the life of me I can't imagine why I never thought of it earlier! What caught my eye was the way that the silver birches stood out against the mill. I used pale tints of burnt sienna to suggest the buds and fine

77

**Snow on the Doniford Stream, Yard Farm**

356 x 508 mm (14 x 20 in)

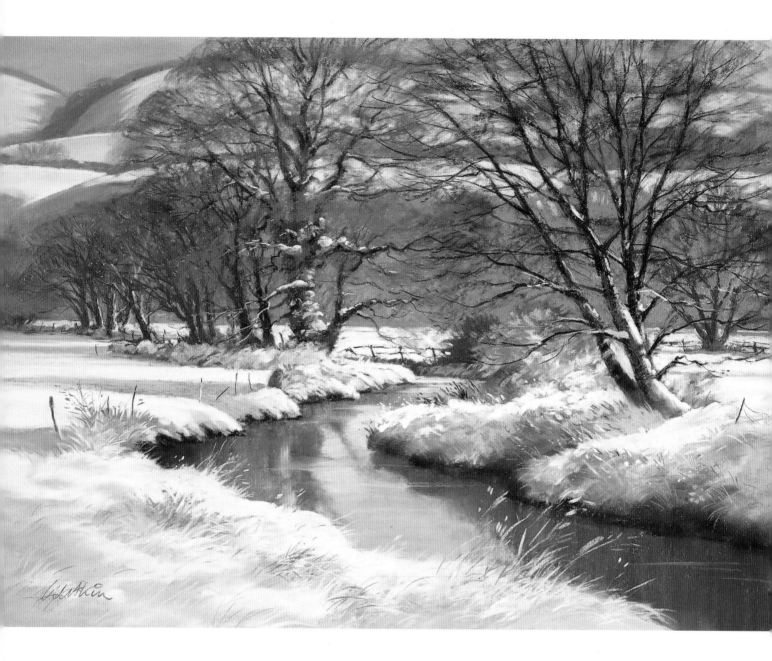

branches catching the sunshine, Naples yellow for the trunks and dark tones of autumn brown and olive green for the bushes, to provide strong contrasts. The cool, shadow side of the snow on these bushes was painted with a pale blue-grey.

For warmth I used pale Naples yellow for the snow in sunlight; had I used white it would have looked very cold. The long shadows help to break up the foreground.

Fishermen's hand heaters are just the job for winter work. I start painting with my right hand while the other clasps a heater in my pocket. When my right hand seizes up I change hands! It is amazing how ambidextrous you become over the years! Of course you can always retreat to the car (presuming you were able to get it out of the garage) or paint from a window or conservatory at home. Alternatively make sketches on the spot with notes on colour and tone (not forgetting to jot down the time) and paint from these later.

I remember one occasion when, painting in a near blizzard, I turned my back on my easel to acknowledge a would-be well-wisher when, without any warning, a sudden gust had my painting and easel face down in the snow! If you must paint in these conditions then make sure your easel is properly tethered.

A tip you may find useful when tackling winter subjects is to make sure you do not over-tighten the wing nuts on your easel. You may end up, as I did, having to ask a passing dog walker to undo them because your fingers are too numb! *Snow on the Doniford Stream, Yard Farm* was painted in February, after a heavy snow fall. I have emphasized the snow-covered branches of the old oak tree on the bend of the river which flows through our land. I enjoyed working a variety of colours into the shadow areas, some of which you can just detect in the foreground. Note also the still green-grey of the water and the accents of yellow and burnt sienna in the grasses protruding from the snow on the river bank. The background is quite simply stated in blue, blue-grey and purple-grey.

# Coasts

*Whenever possible, I advise you to seek out the real teacher — the sea itself... smell the salty air and listen to the music of the moving water. Let the moods of the sea be your moods, and watch for your moods in the sea.*

E. John Robinson

Coastal scenes, seascapes and harbours all have much to offer the painter, yet the challenges are very different. A coastal scene is basically a landscape with cliffs or headland where the sea plays a relatively minor role, whereas in a seascape the roles are reversed. Harbours are a busy blend of water, boats, jetties and buildings. In this section I shall be looking at all these subjects and advising on how to tackle some of the problems you will encounter.

**Breaking Wave, Woody Bay, North Devon**

356 x 533 mm (14 x 21 in)

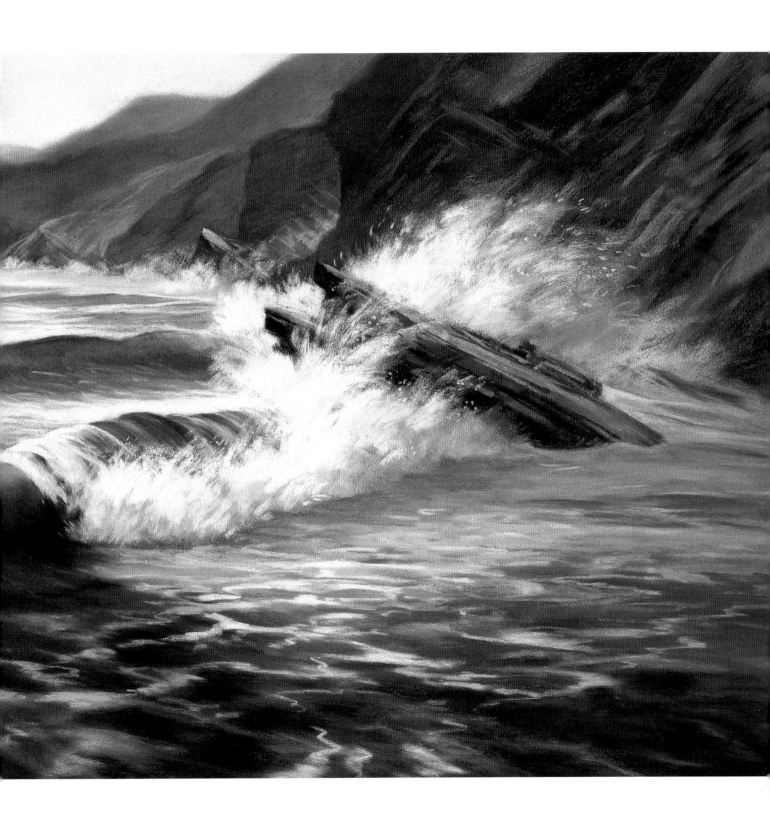

**Caique at Agni, Corfu**
254 x 356 mm (10 x 14 in)

Subject ten

# Coastal Scenes, Seascapes and Harbours

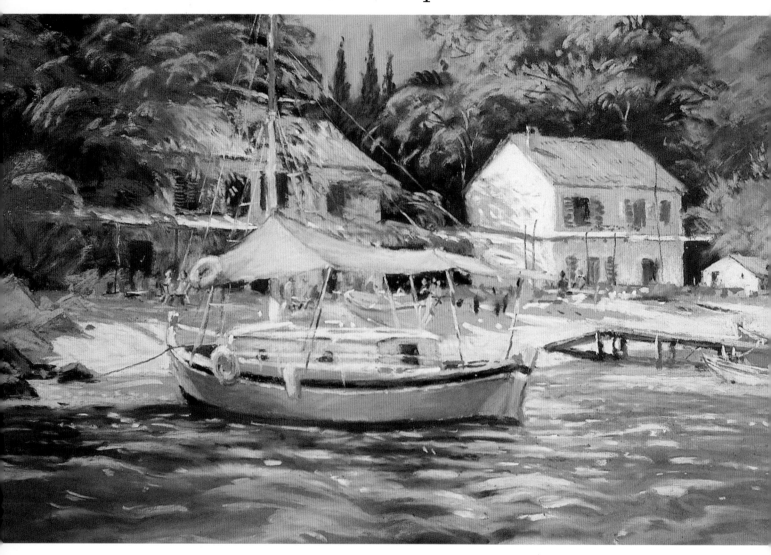

When my children were young, the Greek Islands were a favourite holiday haunt. The acquisition of an old outboard motorboat was not only enormous fun but also enabled us to visit otherwise inaccessible bays. I remember one occasion when I left them all drinking Coca Cola and Domestica (or Domestos as we called it!) at a local Taverna, while I balanced precariously off-shore in our anchored boat endeavouring to paint a caique moored just off the beach. Riding the waves and gripping a parasol between one's knees is hardly conducive to accurate drawing but it proved an exciting challenge, nevertheless! The result is shown above.

**Porlock Bay looking West**

356 x 533 mm (14 x 21 in)

**Sandy Beach near Killary Lough,
Connemara, Ireland**

356 x 533 mm (14 x 21 in)

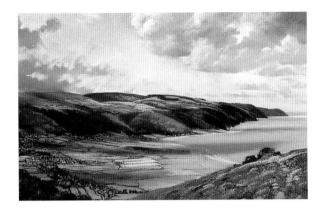

# Coastal Scenes

My painting of *Porlock Bay looking West* was painted from Bossington Hill which is nearly 330 metres (1083 ft) above sea level. This is one of the most spectacular views in North Somerset and presents a daunting subject for any painter.

One of the problems associated with coastal scenes of this nature is that they are often painted while half a gale is blowing off the sea. So it was on this sunny day in August. However the light was superb, the sky magnificent, and when my easel attempted lift-off I abandoned it and continued my work crouched in the comparative shelter of a nearby rock!

The sea is of secondary interest in this painting. However, to add a little sparkle to the background I placed a sliver of light on the water near the horizon. I painted this scene mainly on site and then finished it off in the studio.

A very different scene presented itself in Connemara, Ireland. In *Sandy Beach near Killary Lough, Connemara, Ireland* (see top right) I was intoxicated by the wonderful colours in the sea. Subtle cloud shadows created the contrasts here and the lightest lights were concentrated on the huge sand dunes in the centre of the picture. Two figures at the water's edge gave scale to the painting.

To obtain the effect of shallow water over light sand, paint the sand first and then lightly drag pale blue-grey or green-grey over it until the desired effect is achieved. Waves can be suggested by a few darker green-greys, blending the edges with your fingers before adding pale tints of Naples yellow or white for the breakers near the shore. When water runs back down the beach from a spent wave it creates a pattern of creamy white lines. These too can be dragged on using pale Naples yellow or, if they are in shadow, using pale purple-grey.

83

## Seascapes

Rough seas are always dramatic and present quite a challenge to the painter. My painting at the start of this section depicts a windy day at Woody Bay, North Devon. In it I have tried to capture something of the atmosphere of the scene with waves breaking against the rocks and sunlight shining through the spray. This painting was inspired by a morning spent on location when filming one of my videos.

Note the yellow-green glow at the top of the breaking waves, and the purple-greys of the distant cliffs which give a feeling of recession. Movement and interest are provided in the foreground by eddies and lines of foam streaking across the surface over the darker areas of rock lurking just below. When rocks are wet they reflect the colours in the sky. Shadows from the waves and foam are a mixture of violet and purple-grey.

Seascapes like this provide an enjoyable alternative to landscape but – unless you are very experienced – they are almost impossible to capture on the spot. Time spent observing the movement of the sea, particularly the build-up and break-up of the waves, is of enormous value. Unfortunately, just as it is much more difficult to hit a moving target, similar parallels can be drawn where waves are concerned. If we could but put those relentless forces on hold we would be able to examine them stage by stage and commit them to memory and sketchbook.

Our greatest ally today is the video camera. A wave can be followed through its complete cycle and then played back, either in slow motion or frame by frame. Like anything else, once you understand the principle of how it moves it becomes considerably easier to portray it realistically. I have spent some time studying waves in this way, and the following should help to make the picture clearer for you.

## Cross-section of a wave

Waves and swells are the result of wind and currents in the ocean. Very little appears to take place in the open sea but as the swell moves forward and meets the sloping base of the shore, it is pushed upward and forward until it can no longer support itself (see Fig.13). At this point the top edge, or curl, falls forward and down onto the trough below, exploding in a mass of foam.

Viewed from the shore you will notice that the front of the swell appears slightly concave and is steeper and darker than its flatter backside, while the top is thinner and slightly transparent. This is illustrated in *Force 8 at Bigbury Bay, Devon*. Just as the crest falls forward and begins to break, the top of the wave glows with a yellow-green translucent quality as sunlight filters through it. When the crest curls over, its top, curved surface (or back) grows quite dark before becoming progressively thinner and lighter lower down where

**Force 8 at Bigbury Bay, Devon**

254 x 356 mm (10 x 14 in)

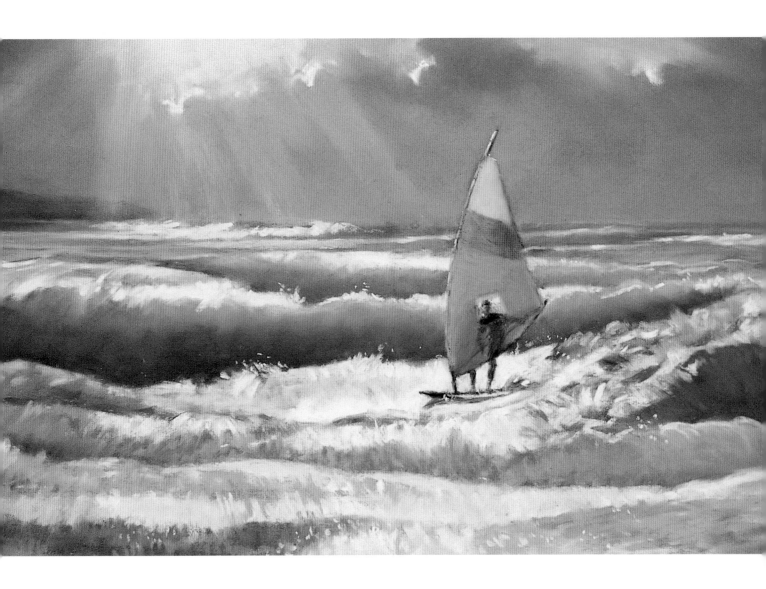

**Fig.13 Cross-section through waves.**

The surface of the sea does not move, only the rolling orbs of energy depicted here by (a), (b) and (c). When these are pushed upwards by the sloping sea bed the front face of the wave becomes steeper (b) and finally curls forward and breaks onto the beach (c).

**Detail of a Breaking Wave**

This shows how dark the back of the wave is compared to the trough behind it and the foam in front of it. Directional pastel strokes describe the movement of the foam as it bursts upwards and catches the sunlight, and a few drops of spray add the necessary sparkle. Purple-grey, violet, blue and green are used in the shadow areas.

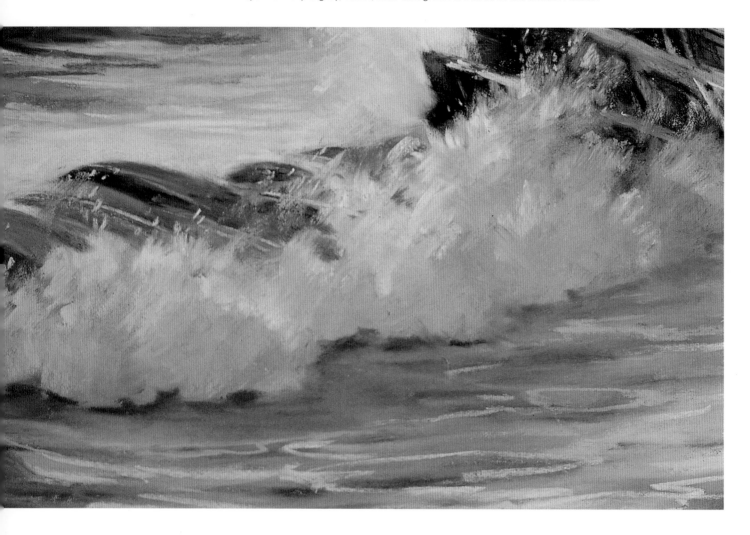

it begins to break up. The darkest tones in a wave are at its base where the shadow from the breaking crest falls.

When the sun is behind, or slightly to one side of a breaker, its shadow will be cast onto the trough in front, producing some wonderful violet hues (see *Detail of a Breaking Wave*). Reflected light, whether from the blue sky or the sun, affects the overall scene. Troughs, being flatter, pick up the lighter sky colours and sunlight

adds warmth to the foam and spray. The colour of the sea is determined by its locality, the depth and colour of the sea bed and the quality of the light. In the Caribbean where the sand is white, the water clear and the light intense, one gets wonderful shades of aquamarine compared to the cooler greys and greens of the English Channel. Which reminds me, do remember to take a few extra colours when travelling abroad!

**'Breeze' at Porlock Weir**

559 x 407 mm (22 x 16 in)

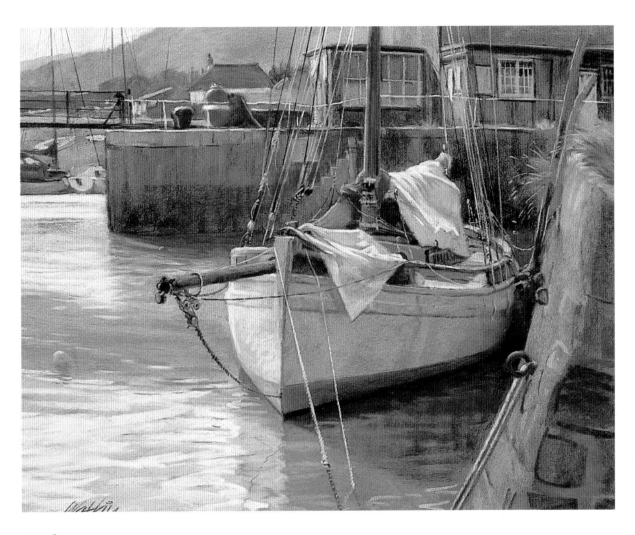

## Harbours

We can't leave this section without a look at harbours, where there is always an abundance of material for the painter. Traditional timber-built fishing boats, Thames barges, or a cutter moored alongside an old quay or tucked away down some quiet backwater, have all the ingredients needed for a rewarding and fascinating day's painting.

At Porlock Weir there is an old Bristol Channel Pilot Cutter which is well over 100 years old and still active. My painting of this fine vessel, *'Breeze' at Porlock Weir*, represents many hours of work, because I wanted to see how accurately I could portray the detail using sharpened pastels. This exercise required patience, a couple of razor blades and a steady hand, particularly when it came to the mooring lines and rigging.

The hardest part of painting is learning how to 'see' your subject, and never more

**Fig.14 Boat formation**

A shallow 'figure of eight' describes the lines of a boat. The side (or gunwhale) of the boat nearest the viewer has a very pronounced curve compared to its opposite. This also applies when a boat is viewed from above although the difference is less pronounced.

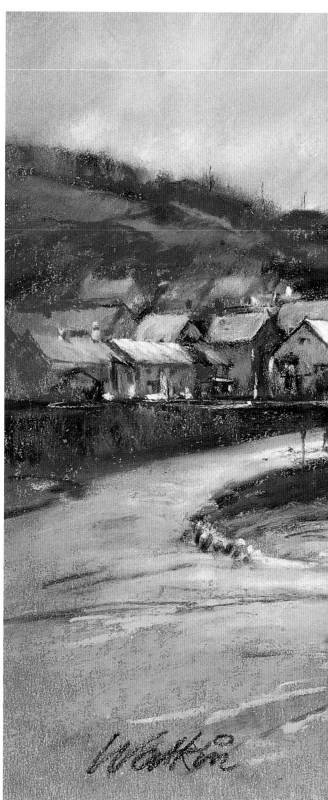

so than when it comes to getting the shape of a boat right. We've all seen boats in paintings that could never go to sea – or if they did they wouldn't come back – and the best tip I can offer is that old chestnut, the figure of eight. Have a look at Fig. 14, which will make matters clearer than any number of words from me.

Our nearest harbour is at Watchet which, until 1993, was a working port, albeit on a very small scale. One morning I made some sketches and started work on a limited palette painting in which I simplified all the statements to enhance the feeling of soft morning light. In *Early Morning, Watchet Harbour*, only one of the cottages has a light in its window. It was tempting to add more!

**Early Morning, Watchet Harbour**
330 x 533 mm (13 x 21 in)

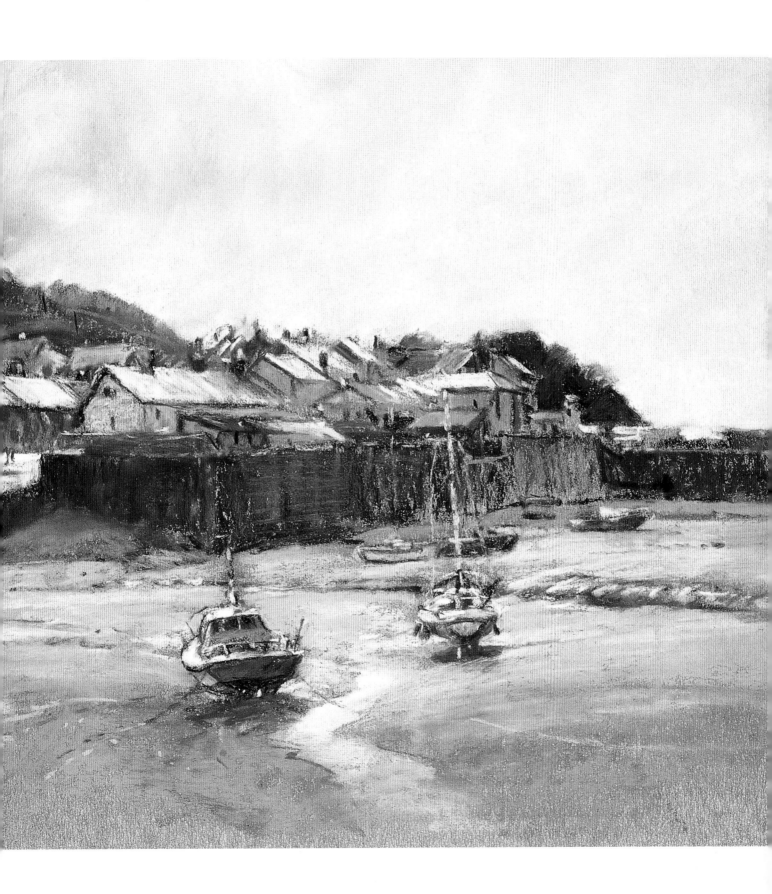

# Flowers

*A thing of beauty is a joy forever:*
*Its loveliness increases; it will never*
*Pass into nothingness; but still will keep*
*A bower quiet for us, and a sleep*
*Full of sweet dreams, and health and*
*quiet breathing.*

*John Keats (1795-1821)*

For centuries artists have been fascinated by flowers —
their infinite variety of form and nature's unlimited
palette presenting an irresistible challenge.

**Tally Ho Rhododendron**

470 x 622 mm (18½ x 24½ in)

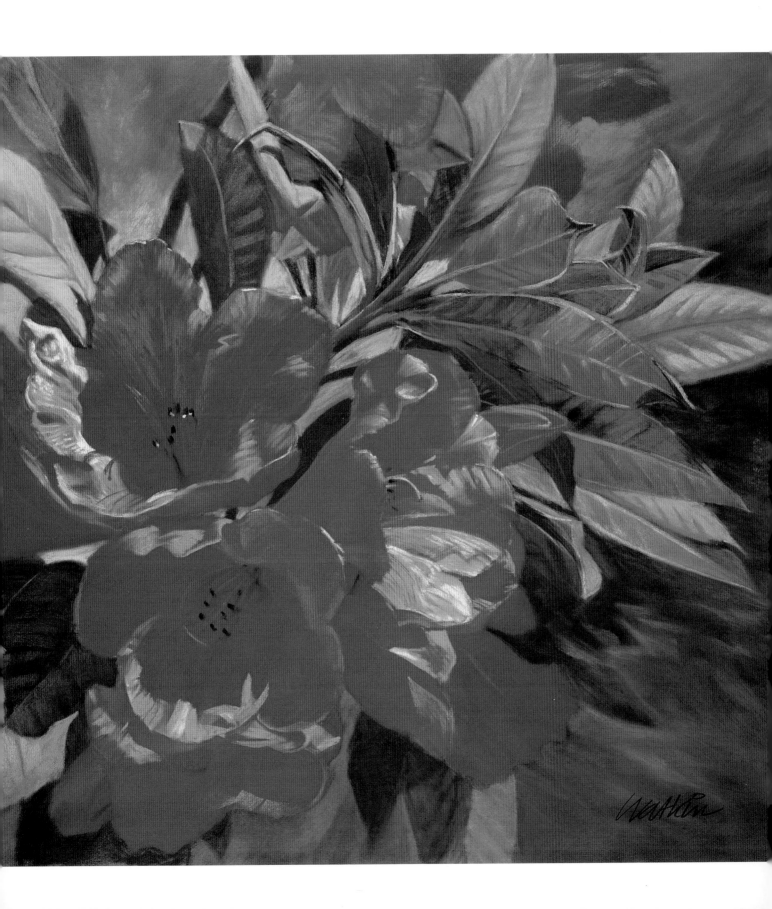

Subject eleven

# Flowers in Your Garden

Every year in June around twenty gardens
in our village are opened to the public.
During the week leading up to this
colourful event we run a Flowers and
Gardens Course which in effect means
unleashing our eager and excited students
into three of the gardens. My problem
is chanelling all this enthusiasm into
something tangible on paper. For the first
ten minutes or so there is only the buzz
of animated conversation as members
swoop onto the plants like a swarm of
demented bees. Cries of *'Paeonia
Lactiflora'*, *'Incarvillea Delavayi'* and
*'Ornithogalum Umbellatum'* ride the air
and the sketch-book is all but forgotten.
But putting off the moment of truth
because you cannot decide what to paint
or from which angle wastes precious time.
Here are a few pointers which should help
speed up the selection process.

## Choosing Your Subject

First decide whether you want a general view
of the garden, a small corner or just a
single bloom. The first option poses more
problems because there are numerous
ingredients clamouring for your attention
and you must decide which to give
prominence and which to play down. The
corner is easier because the information is
condensed into a smaller area and the
single bloom lends itself to either a
detailed study or an impression,

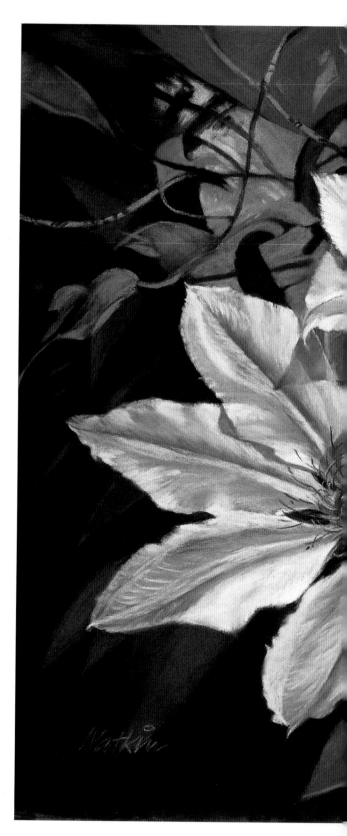

**Nelly Moser Clematis**
470 x 622 mm (18½ x 24½ in)

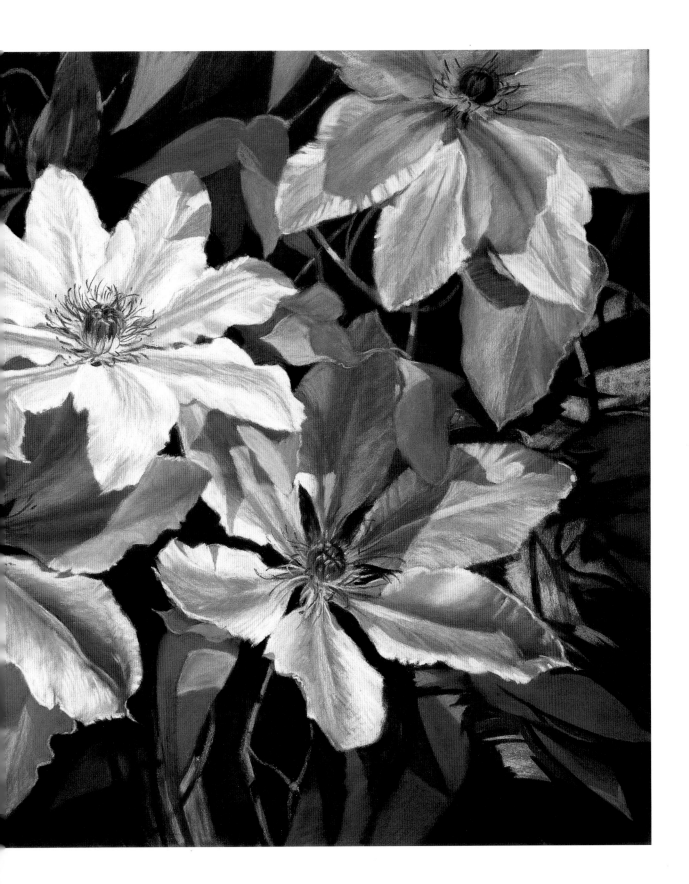

**Fig.15 Exercise in values**

Reduced to black and white, the pink geranium

is almost as dark as its surroundings

## Flower Colours

Flowers provide the artist with the opportunity to indulge in some stunning colours backed up with the more familiar greens and greys of leaves and backgrounds. Ideally you should have a separate box of pastels for flower painting. Every time well-meaning aunts – who have a propensity for this sort of thing – send you a box of pastels for your birthday, remove all the bright colours and pop them straight into your flower set. Over the years you will acquire quite a selection of brilliant hues from various makers. It is a case of 'the more the merrier'. You can't have too many pastels when it comes to matching the subtle tones and colours found in flowers.

depending on your whim. Whatever you decide, the viewfinder will be invaluable in sorting out your composition. First establish your focal point and balance it with a feature of lesser interest. Now decide how you can bring recession or depth into the painting. Position yourself so that your main subject or focal point is in strong light against a dark background. This will give punch to the picture. It helps if the sun is from the side rather than behind you. The pattern of shadows can be quite exciting and cast shadows can be used to direct the eye towards the focal point.

The next step is to try one or two sketches, to work out the tonal balance and general arrangement. This is particularly relevant if you are painting red flowers such as paeonies or azaleas. Red is very dark on the tonal scale and can get 'lost' among the greens. In the black-and-white reproduction (Fig.15) of a dark pink geranium you can see that it is only slightly lighter in tone than the surrounding leaves.

Probably the most difficult aspect of flower painting is capturing the subtler tones to be found in a bloom at close quarters. An example of this is shown in my painting of a Nelly Moser Clematis at the beginning of this section on pages 92-93. Notice how the lightest central flower overlaps and casts a strong shadow over the slightly darker one beneath it. Cast shadows, remember, are darker than areas in shadow because they do not normally receive any reflected light. To vary the weight of tone I painted the cast shadow over the bloom on the right cooler and slightly lighter than the central one, and varied the tone and colour of all three main blooms. I restricted the highlights to areas which directly reflected the sun's rays.

**Albertine Roses**

254 x 330 mm (10 x 13 in)

**Sketch of Hollyhocks**

305 x 229 mm (12 x 9 in)

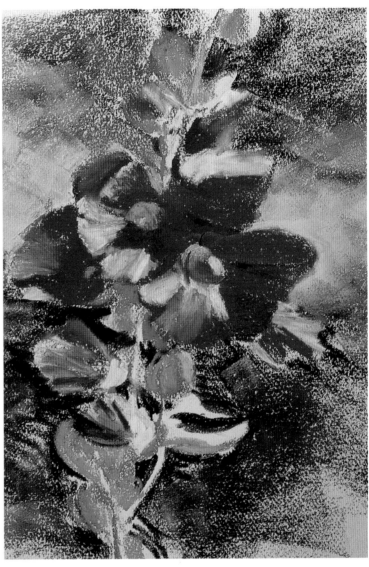

To create maximum visual impact I enlarged the flowers to twice their actual size which enabled me to describe them in great detail. The dark, slightly out-of-focus background provides the necessary contrast for the light flowers.

*Albertine Roses* was the result of a much simpler approach. This was a demonstration painting which I did outdoors for students and I kept detail to a minimum. I painted it on a quarter imperial sheet of Hermes glasspaper and used Unison pastels for the blooms and Schmincke for the leaves. Notice how I treated the leaves very simply, putting in only the essential areas of colour rather than every twist and vein.

By way of a contrast my *Sketch of Hollyhocks* was made to show students how to block in the main shapes with areas of flat colour before adding half tones and lights. The result is very free and lively and yet captures the essential character of these lofty flowers.

95

**Sweet Peas**

356 x 533 mm (14 x 21 in)

# Sweet Peas, Roses and Wild Flowers

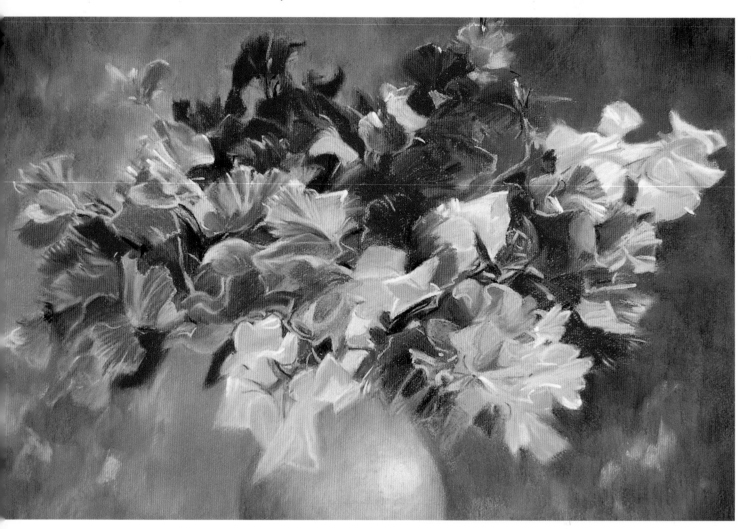

It is not always possible to paint outdoors. Indeed, many artists prefer to paint in the comfort of the more controlled conditions of the garden room, conservatory or studio. My painting *Sweet Peas* was a joyous adventure in colour and light. My mother, a spry octogenarian, had just put the finishing touches to an arrangement in the sitting room for our guests to enjoy when I walked through, spotted them, and as she later remarked, 'There they were –

gone!' There is something very appealing about sweet peas, with their unusually shaped blooms, gorgeous colouring and minimal leaves. My original intention was to produce a free impression of the subject and for that reason I chose a sheet of pale blue-grey Canson paper. However, as the painting progressed I became more and more involved with the shapes of the flowers and ended up with a complete painting with no paper showing through,

**Roses in a Silver Kettle**

241 x 318 mm (9½ x 12½ in)

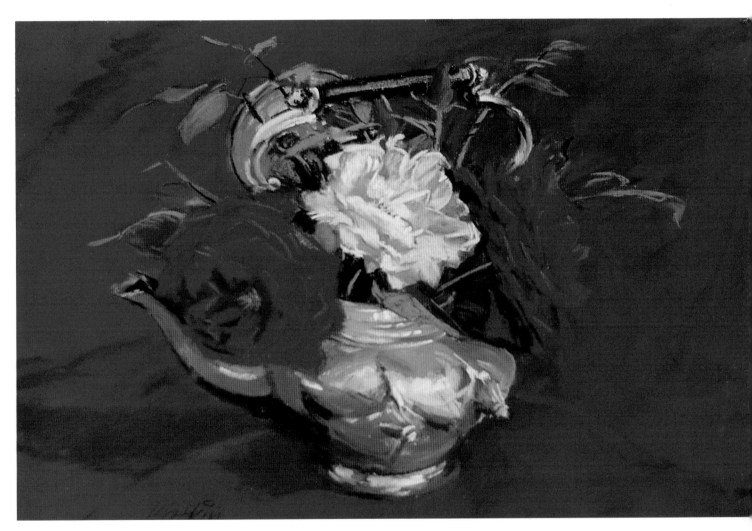

an approach normally reserved for glasspaper. Both the pot and the table are only hinted at in order not to detract from the flowers.

For the background I used a mixture of warm greys, olive greens, red-greys and hints of pale yellow ochre. As in a portrait, it is important that one side of the background is darker than the other in order to counterchange lights and darks.

*Red Roses in an Antique Silver Kettle* was my wife's idea; I must admit that I was not entirely convinced about the red drape. Muttering about reds and dark greens, I became immersed in the painting and once I had stopped grumbling, could hardly wait to tackle the gorgeous reflections on the kettle. My wife liked it so much that she was given it for Christmas!

**Bluebell Wood, Boxhill, Surrey**

356 x 533mm (14 x 21in)

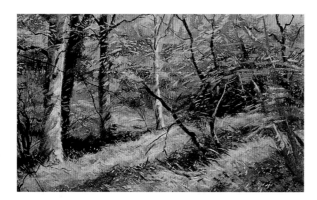

## Wild Flowers

Whenever possible I prefer to paint wild
flowers in their natural habitat, but if you
are not keen on working alone in a field
or wood, take some flowers home and put
them in a jam jar on the window sill.

*Bluebell Wood, Boxhill, Surrey,* was painted
on glasspaper. For the bluebells I used
ultramarine, mauve and purple-grey. It is
important to simplify the main areas of
blue – both light and dark – adding hints
of mauve and purple to vary the overall
effect. Individual flowers, in contrasting
tones, can be added where you need
emphasis. We are conditioned by years of
looking at things superficially and it is not
until we make statements in paint or
pencil that we realise how little we
understand about tone, colour and form.
Green leaves (particularly shiny ones) are
not green under a blue sky; a sunlit pink
geranium needs more colours than three
shades of the same pink to look
convincing; a white rose will contain
subtle nuances of many other colours,
particularly when surrounded by yellow-
green leaves or other strong influences. So
take time to observe.

# Demonstration: Arthur Bell Rose

Picking my way through my students in the
Rose garden one hot July afternoon, I was
struck by the sight of a delicate Arthur Bell
rose against an old wall. What attracted me
was the contrast of the cast shadows, the
warm glow of reflected light and the rich
colour at its centre. What followed was the
following impromptu demonstration.

**Paper:** Canson Mi-Teintes, pale blue-grey
(No. 354)
**Pastels:** Rowney and Unison

### *Stage 1*

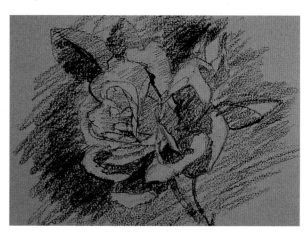

I drew in the main shapes with charcoal,
indicating the cast shadows on the lower
petals and the position of the leaves and
stalks. Half tones were indicated lightly
and darks were then added to give
contrast. The drawing was then fixed.

## Stage 2

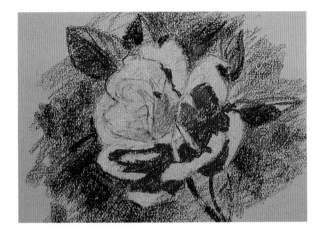

Dark blue-violet was laid over the cast shadows and any dark accents, followed by a light application of cadmium yellow over the remaining petals. Naples yellow was used for the warmer area in the centre. Dark green-grey was then added to the leaves and background varying the pressure here and there. The stalks were emphasized with Vandyke brown and burnt sienna.

## Stage 3

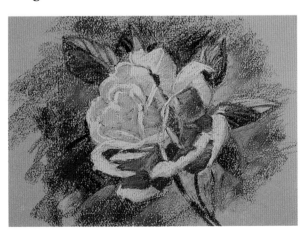

I put in the lights with yellow ochre and sap green and added warm grey to the background. For the bud I used burnt sienna plus cadmium yellow for the lighter accents.

## Final stage

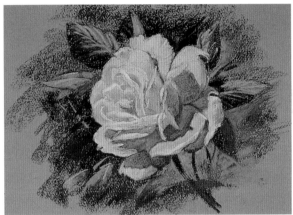

All areas of the painting were developed and refined, lightening and warming the cast shadows with Naples yellow and lemon yellow and adding a little green-grey in the cooler areas. The glow of the central area was enriched and more mid-tone lemon yellow applied to the petals. Touches of pale blue-grey and indigo were added where cool colours from the sky reflected on the shiny petals and leaves. A few darks sharpened up the drawing and some highlights on the edges of petals and leaves completed the picture.

# Life and Interest

*I go among the fields and catch a glimpse of
a stoat or a fieldmouse peeping out of the
withered grass — the creature hath a purpose
and its eyes are bright with it. I go amongst
the buildings of a city and I see a man hurrying
along to what? The Creature has a purpose and
his eyes are bright with it.*

*John Keats (1795-1821)*

In this section I want to discuss incorporating details
such as butterflies, figures, animals, birds or garden
implements, all of which create additional interest
within the composition and do much to bring a
painting to life.

**Peacock Butterfly and Delphiniums**

458 x 610 mm (18 x 24 in)

**Dunster by Candlelight**
356 x 483 mm (14 x 19 in)

# The Imaginative Touch

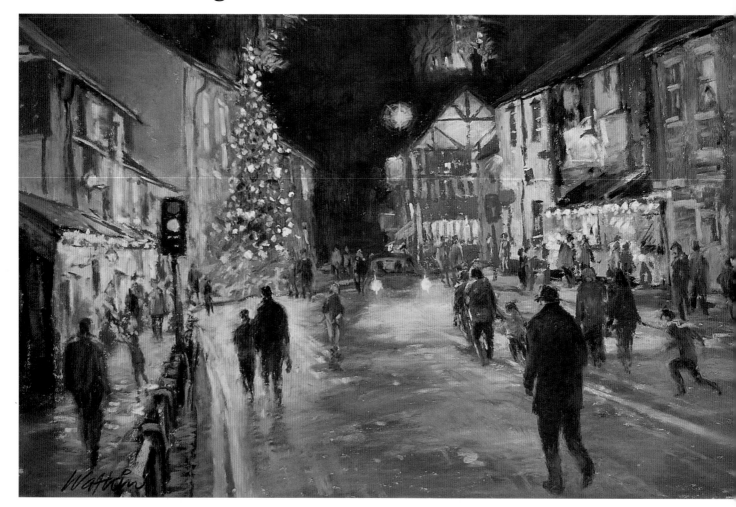

## Painting People

*Dunster by Candlelight* was painted just before Christmas when this medieval village has its annual celebration. The castle in the background is illuminated for the occasion and all the shops are decorated and lit by candles. The glow of the lights reflected on the wet road, the Christmas tree, the crowds, even the traffic lights, all help towards creating an interesting and unusual painting.

Competence with figures takes a lot of practice. Until you are completely at ease with the subject it is better to place figures in the middle distance rather than the foreground. Suggestion is the key to success. Too much detail tends to kill any movement and make the figures look wooden. We cannot paint what we do not understand. Life drawing classes may help but you can achieve much more by keen

102

**Fig. 16** On a level road heads of pedestrians will appear near or on the eye-level. Doorways provide useful clues to the scale of pedestrians and lines projected from common vanishing points help when assessing the height of figures in the foreground.

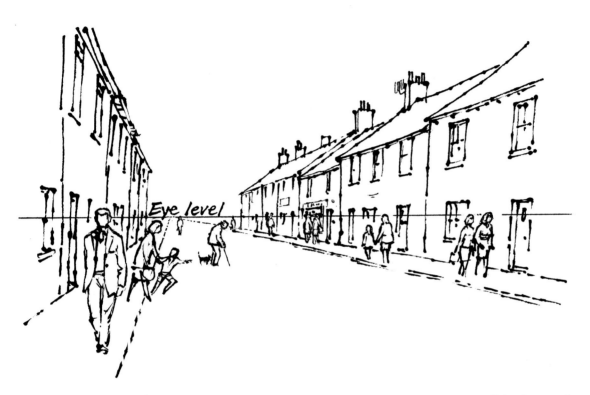

observation and by getting into the habit of using your sketchbook. Alternatively, take photographs, preferably black-and-white, and make sketches from these. It is considerably easier to sketch moving figures from photographs because the camera stops the action. Video cameras are also invaluable. A sequence of figures in action can be played back frame by frame until the required position is located and then held while you make your sketch. Remember to half close your eyes and look for the main shapes, ignoring detail, and fade the legs with just a suggestion of tone making one leg darker than the other. This creates movement. Unless your figure is placed right in the foreground of your composition, do not put the feet in.

Figures nearer to you will be larger than those in the distance, so watch your scale. Treat them like buildings, using doorways as a guide to their height. Look at Fig. 16. This shows you how to get the relative sizes right. We don't want midgets in the foreground and giants in the distance!

If you have a chance, look up some of the paintings by the British artists Edward Seago, Edward Wesson or Trevor Chamberlain. Much can be learned from studying their work and seeing the way each of them handles figures.

103

**Quay Street, Lymington**

356 x 483 mm (14 x 19 in)

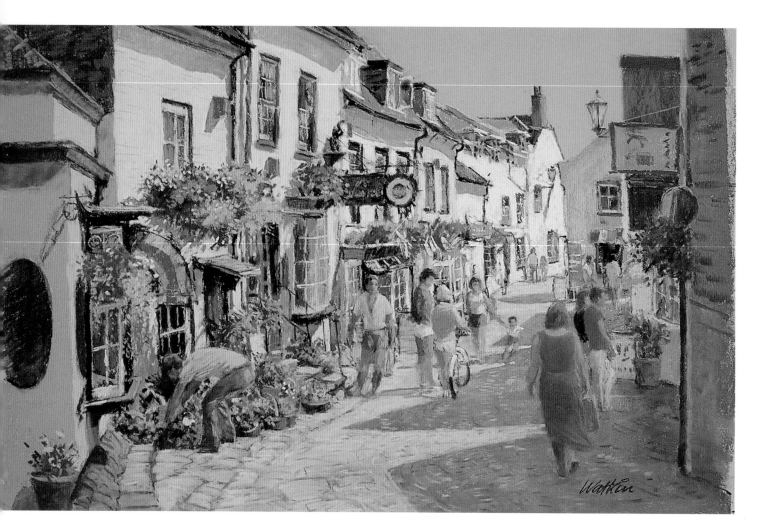

## Café Scene

Most of us when holidaying abroad have stopped for a cool drink or a coffee under a gaily striped umbrella, or wandered among the locals sitting at tables under the trees on the busy piazzas. What an opportunity for the artist. Take a look at my picture on page 111, *The Fountain El Paseo* painted from a sketch made while on holiday in California. A subject like this relies heavily on accurate drawing, tonal values and composition. It is as well to spend a little time deciding what we really want to paint. Don't try to take in too much or you'll blow a fuse. Treat faces as one tone, either light (in sunshine) or dark (in shadow). Suggest, as economically as you can, the darker areas around the eyes and the side of the nose. Figures sitting, lounging or standing at a table are fascinating, and when combined with chairs and parasol poles, together with their shadows, can produce some very interesting angles.

104

**Last Man In**

Detail from cricket match at Winsford, Exmoor.

Use your imagination when putting figures into your paintings. People are either coming or going, working or playing, walking their dog, pushing the baby or just admiring the baby. One way or another there is always a story behind their actions. Plan their positioning for maximum effect. Some should be in shadow and others in light.

When painting a townscape or busy street scene, place some figures in a group and place one or two separately. An example of this is shown in *Quay Street, Lymington* (opposite) which was painted over three hot afternoons one August. Because my time was limited and the street was packed with holiday makers, I sketched the florist putting out her flower baskets and took photographs of interesting individuals in the crowd. From these I was able to complete the picture.

I find the contrast and pattern of white figures against green backgrounds in cricket matches very interesting, and I have included a detail from a sketch made at Winsford, *Last Man In*, which shows a close-up of some of the players. At the same time I videoed some of the action and this came in useful later when sorting out the final painting. But nothing can replace the value of the sketchbook; the very act of striving to record images on paper becomes etched on the mind in a way that copying from photographs or film can never quite equal.

**Detail from Sheep and Shepherd at Over Stowey**

## Painting Animals

A general landscape can be transformed by the
addition of sheep or cattle grazing. Sheep
in the foreground require a little care. They
may look shapeless but closer observation
will reveal strong facial characteristics and
very clear cut 'back ends'. The detail from
my painting *Sheep and Shepherd at Over
Stowey* was painted from memory! My
favourite cows are Fresians. Their black-
and-white chequer-board patterns provide
a wonderful contrast to the colour around
them. A group grazing under trees (as in
*Rich Pastures*), or by a river, provides a fine
subject. If they are in the middle fore-
ground you can have great fun suggesting
their shape with blocks of dark and light
plus a few angled strokes for legs. You
don't need forty legs for ten cows.
I remember the late Edward Wesson
demonstrating to my art group in the
Seventies. He included five Fresians with
fourteen legs in his picture and, as Ted
pointed out, legs are frequently masked
by other legs and people rarely count
them anyway! So three-legged cows are
quite acceptable.

106

**Rich Pastures**
178 x 280 mm (7 x 11 in)

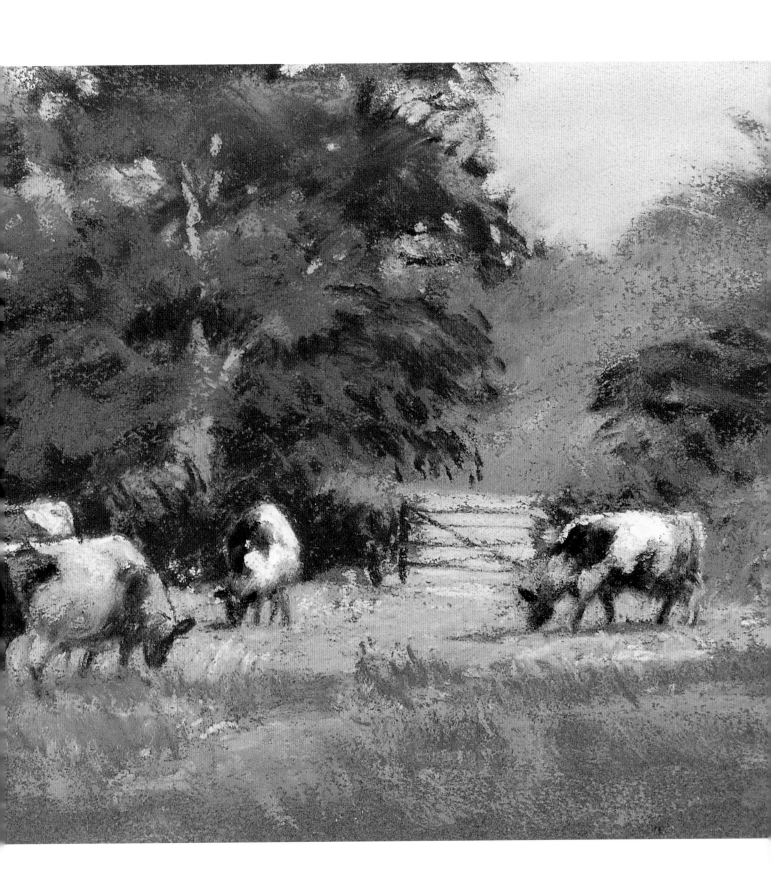

**Steam, Smoke and Snow**

254 x 356 mm (10 x 14 in)

## Capturing the Ambience

I have been a steam enthusiast since I was a boy. As we now live by the West Somerset Railway I can indulge in some train spotting at close quarters. One November I drove to Minehead to make a pastel sketch of the 10.25 before it left the station. Halfway there I ran into heavy snow and things looked very bleak on arrival at the station. I retreated to a level crossing a short distance down the line and was rewarded with the view which you can see in *Steam, Smoke and Snow*.

I still recall my delight at finding the scene which became *Back Gardens*, *Church Cottages*, one autumn morning. The focal point was the glow of light on the wall of the cottages accentuated by the bean sticks

**Back Gardens, Church Cottages**

254 x 356 mm (10 x 14 in)

and the garden shed with the dark open door. But it was the 'bits and pieces' in the foreground that caught my eye – the wired rabbit run, cucumber frame and hen coup; the black-and-white cat sitting by a bucket; the bright green watering can. Beyond all of these, and linking the two sides of the picture, were rows of cabbages which reflected some of the notes in the sky.

Pastel was the perfect medium for the scenes mentioned in this section. It is quick, direct, and it enabled me to capture the fleeting moment – so very important when you are bent on putting life and interest into your work.

109

# Miscellany

*He who resolves never to ransack any mind but his own, will soon be reduced, from mere barrenness, to the poorest of all imitations; he will be obliged to imitate himself, and to repeat what he has before often repeated.*

*Sir Joshua Reynolds (1723-1792)*

This final section covers some special techniques which will provide an added dimension to your work. It also gives you advice on planning a still life and guidance on mounting and framing.

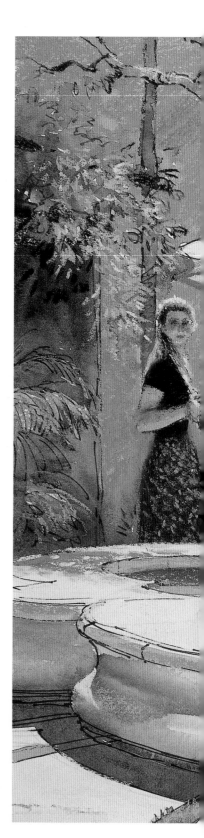

**The Fountain, El Paseo, Santa Barbara, California**

458 x 585 mm (18 x 23 in)

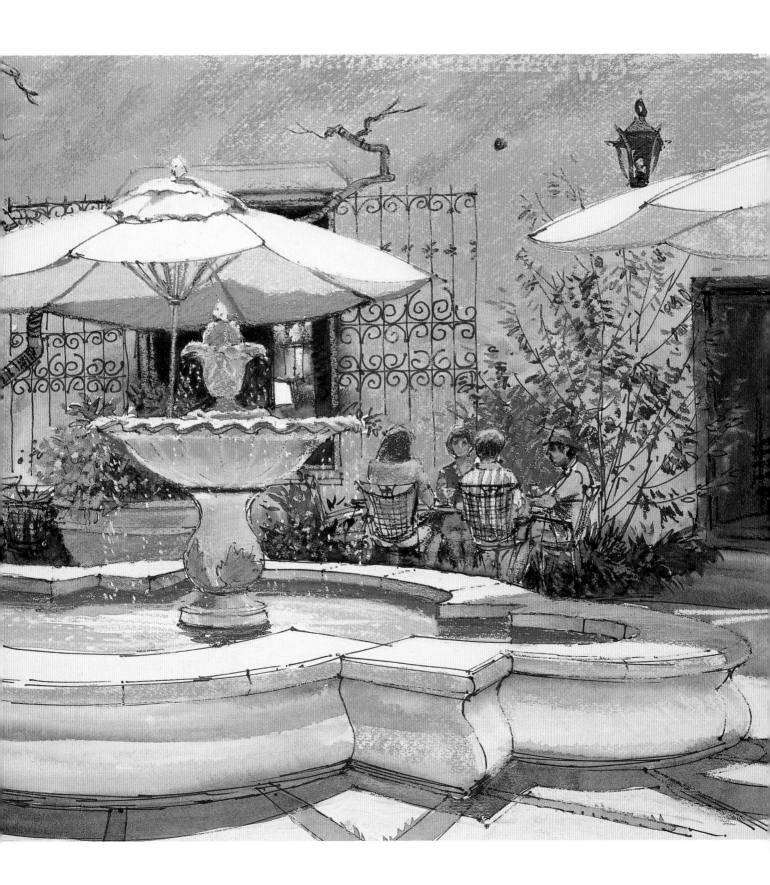

Subject fourteen

# Varying the Approach

Thinking about 'varying the approach' reminded me of a French landscape painter and teacher who once advised his students to look at the scene they were painting upside-down between their legs. He reckoned it was the only way to see things in their true relationship. I am not suggesting you dash out to try this method for yourself but whereas in previous sections we have dealt with the application of pastel in a fairly conventional manner, there are a number of special techniques which can be employed to produce some very interesting effects. Here are some you might care to try.

## Broken Colour

I can state with some certainty that the use of broken colour will add a freedom and vibrancy to your work which, although not in the earth-moving category, will cause a considerable stir at your Art Group's next exhibition.

As the term implies, we introduce various colours of similar value and apply them lightly, layer upon layer, with short, blocking strokes. By playing the complementaries we can obtain some very exciting effects. For example: reds, pinks and browns into greens; yellows and oranges into blues and so on. Have a look at my sketch of an Australian sky at the top of this page. Here I have used a range of blues, blue-greys, purple-greys, yellows,

**Australian Sky, Blue Mountains, New South Wales**

254 x 356 mm (10 x 14 in)

greens and reds in the 'blue' of the sky with lighter hints of the same in the clouds. A sky makes an ideal subject with which to experiment before going on to trees, hills and buildings. Fresher, more interesting results are achieved if merging is kept to the minimum.

## Pastel Over Watercolour

Take a sheet of pale Canson paper (No. 407 cream or No. 335 white), lay it on a table and fold the edges around a piece of hardboard, leaving about 36 mm (1½ in) overlap all round. Fold over each long side and tape them down using 50 mm (2 in) masking tape. Do the same with the two short sides. It is important that you pull the paper over the edges as tightly as possible. When secure, soak the surface with a wet sponge and allow to dry overnight. Alternatively, stretch the paper as you would a sheet of watercolour paper, with gummed tape. Now lightly pencil in the main shapes of your subject and with the largest brush you can manage lay in your watercolour simply and boldly. Don't be afraid to make the darks really dark and don't panic if some of the colours run – it will all add interest.

The object of this exercise is to provide a strong, loose impression of your subject with no detail whatsoever. You will find this 'loosening up' approach extremely beneficial, particularly if you tend to be a little tight with your watercolours. When this has dried – and the paper is flat again – go in with your pastels. Strengthen the drawing here and there and pull the whole

thing together with a few well-placed details. An example of this is shown in my painting *The Stable, Yard Farm*. This is an interesting way to use pastel – it not only provides more texture but has the great advantage of establishing really juicy darks over which lighter colours can be dragged, resulting in delightful dry-brush effects. As an alternative to pastel paper try a NOT surface watercolour paper (Fabriano Artistico 640 gsm/300 lb is very sympathetic and does not require stretching), or one of the tinted Bockingford papers (which does need to be stretched).

## Inking-in the Darks

If your subject includes a lot of darks – an evening or moonlight scene for example – it makes sense to wash them in using sepia, Indian ink (diluted or neat) or any dark watercolour mix: burnt umber and Prussian blue is ideal. When dry, use your pastels to bring up the middle tones and lights. Because the ink provides the really dark darks the tooth of the paper is still present and allows lighter pastels to be dragged over them producing interesting textures. This method is better suited to a tinted watercolour paper or preferably a mid-tone Canson. In either case they should be stretched to avoid puddles of pigment collecting in the hollows and pastel only touching the ridges. Applying pastel to a smooth, stretched surface is an enjoyable experience, but trying to cope with dips and humps is not.

**The Stable, Yard Farm**

356 x 533 mm (14 x 21 in)

Boaters Farm
1/7/92

## Linear and Feathering

For this technique, rather than sweeping a
  stick of pastel on its side across the paper
  we make lines using the edge of the pastel.
  Look at my painting, *Farmer Hayes' Barn.*
  I used pale blue-grey Canson (No. 354)
  and, after indicating the main shapes
  lightly with a mid grey pastel, started with
  the sky, drawing near-vertical lines of pale
  coeuruleum, purple-grey, orange and blue-
  green. In order to gradate the sky from
  dark down to light I feathered my strokes
  off as I merged the various colours
  together. It is important to use colours of
  similar value to avoid unevenness.

The background hills and trees went in
  next using mixes of purple-grey, grey-
  green, blue-grey and some Schmincke
  green. For the lights in the barn I used a
  mixture of burnt sienna, yellow ochre and
  burnt umber with deep purple-grey and
  red-grey for the darks. A number of
  warmer greens were used for the field
  with lemon yellow and a touch of
  cadmium yellow for the pale accents in
  front of the barn. For the tree on the left I
  used directional lines of a darker green to
  suggest the form of the foliage with red-
  grey and blue-grey for the trunk. This
  method is easier to handle if you use hard
  pastels (or pastel pencils) which will
  produce finer lines with less smudging.

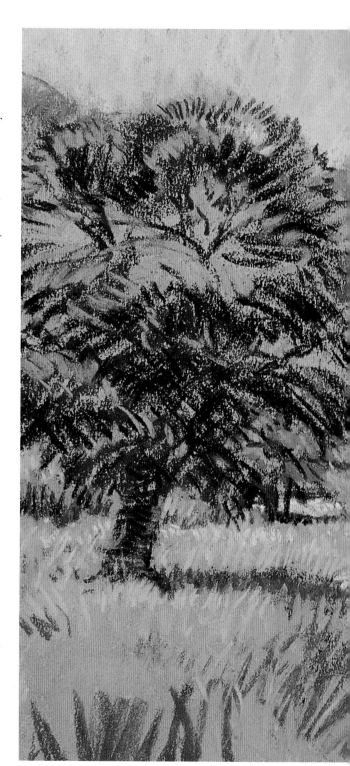

**Farmer Hayes' Barn**

305 x 483 mm (12 x 19 in)

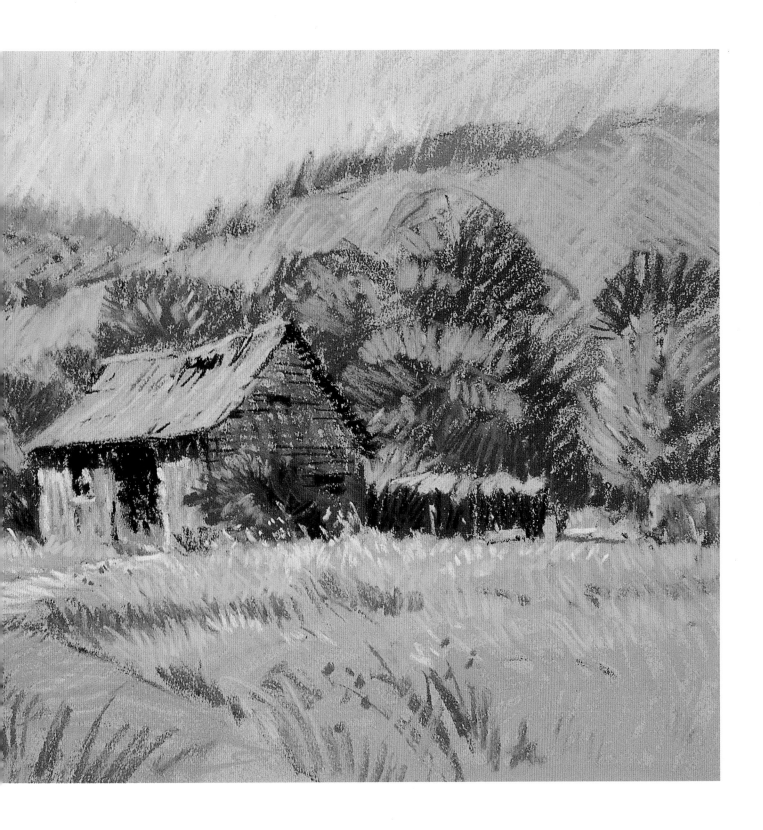

## Mixed Media

An example of mixed media – *The Fountain, El Paseo, Santa Barbara, California* – appears at the beginning of this section. In this I have combined watercolour, black marker pen, crayon, pastel and charcoal. As you become more confident with pastel you should consider experimenting with different materials. Mixing pastel with gouache, charcoal, thinned oil paint, pastel pencils and ink, either all together or in any combination, will open up a host of possibilities. Degas often used pastel over a prepared ground because the underlying texture lent greater interest to the work. Try things out, break rules, throw caution to the winds. It may not work every time but you'll learn from the experience and it will be fun doing it. Below I have outlined an excerise which you may care to try.

Take a piece of watercolour paper, NOT surface, stretch it and place it on a board. While it is drying, set up a still life, either close to a window or with a spotlight. Use a variety of objects employing different surfaces and textures such as glass, pottery, copper, fabric and so on. Now with a large brush, wash in the main shapes with acrylic, gouache or watercolour. If anything, err on the dark side because tones can be lightened later. Keep your brushstrokes loose and don't worry if the paint runs. When the paper is dry, firm up the drawing with charcoal and give it a spray with fixative. Then go in again with gouache or acrylic, strengthening colours and establishing the darks. Let that dry and start pulling the painting together with pastel.

Coloured inks or Indian ink can also be incorporated, but these should be applied before you get to the pastel stage, either with a sharpened stick or brush. Ink or paint can be splattered by flicking it onto the paper with a brush, or better still, a toothbrush (which provides a finer spray). Add the final details, place a few highlights and then stop!

## Building up Layers

This is where the use of fixative is beneficial to the process. Try this exercise on a sheet of glasspaper because it not only takes more pastel but is stronger than conventional papers. Clip a half imperial sheet onto your board and lightly indicate your subject with charcoal. Start with something fairly simple. Our concern is more with shape and texture than drawing, and hopefully the introduction of some vibrant colour. Try to visualize the finished painting in your mind's eye (a few colour sketches will help here), then lay in the first light application of pastel leaving some of the surface of the paper showing through. This will act as a key for the rest of the painting. Fix this layer lightly. Now gradually build up the painting with layers of colour, fixing each layer as you go. This will enable you to keep control and maintain a degree of 'tooth' with each layer. Remember to vary the direction of your strokes – vertical and diagonal are usually the most effective – and do keep the whole painting moving along. A yellow placed alongside a violet

**On the Somerset Levels**

356 x 458 mm (14 x 18 in)

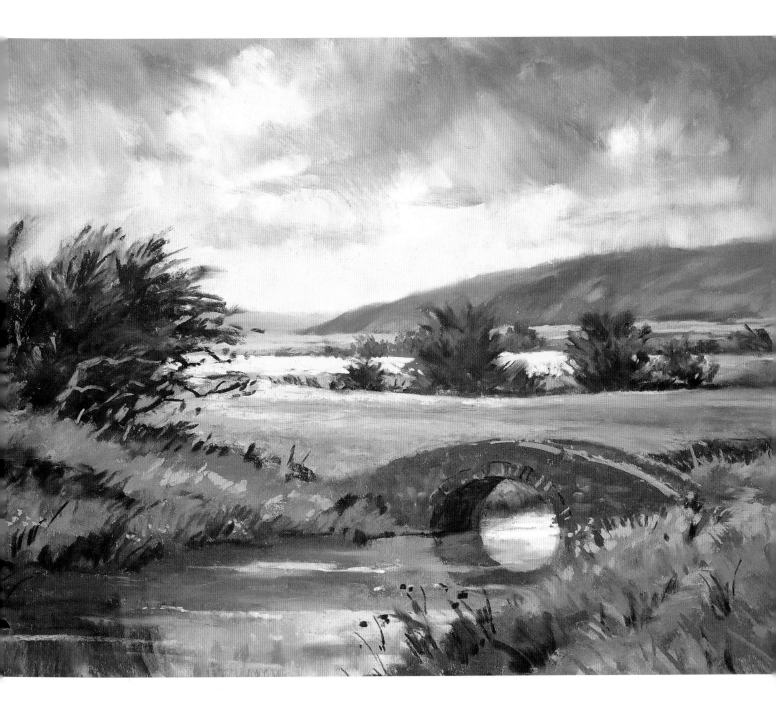

or purple-grey will look very different against a green, so don't concentrate on one area to the exclusion of the rest. When you have made your final statements don't fix them. Fixative darkens pastel quite considerably and, used indiscriminately, will kill the lights and vibrancy you have worked so hard to achieve.

An example of this method, *On the Somerset Levels*, is shown above.

## Pointillism

Surprisingly, of all the techniques covered on my courses, pointillism is the favourite. Certainly it gives students the opportunity to 'have a go' with some of the brighter colours which very rarely get an airing. Pointillism involves painting by means of applying small dots of pure colour side by side on the paper. This produces an effect of near-fusion but, more importantly, it imparts a vibration of colour that is impossible to achieve through the normal mixing process.

If you fancy trying this method, start with a simple landscape or flower arrangement on a piece of Canson or glasspaper no larger than 38 x 28 cm (15 in x 11 in). Indicate the main shapes lightly with charcoal and then begin adding colour in small dots or marks with the corner of your pastels. If you want maximum vibrancy you should concentrate on the complementaries – red with green – blue with orange – yellow with violet. Colours can be lightened where necessary with lighter tints.

In *Trees by the River*, I have used numerous colours, many of them from the spectrum range. Unfortunately soft pastels soon lose their edge and the dots become blobs – harder pastels would be more suitable – but you can still follow the principle and enjoy the visual sensation. My painting is based very loosely on a sketch made of the River Kennett near Ramsbury, Wiltshire.

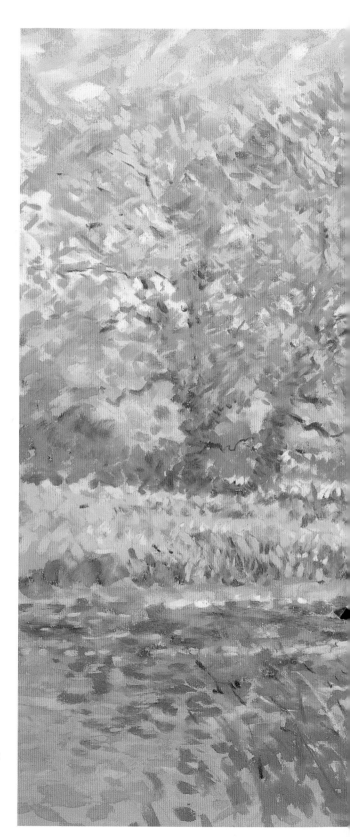

**Trees by the River**
356 x 483 mm (14 x 19 in)

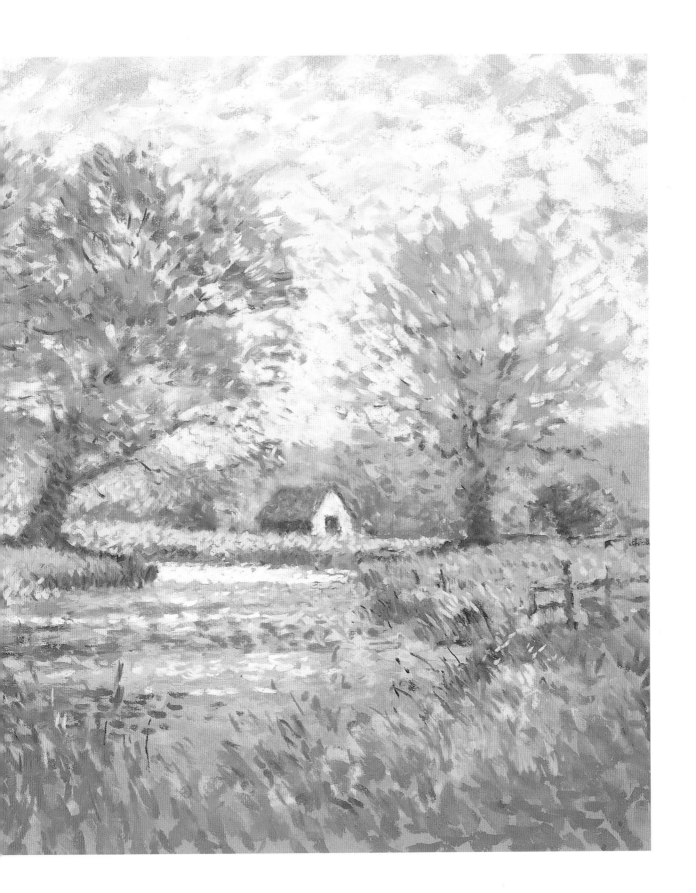

**Still Life, Bowl of Fruit**
254 x 356 mm (10 x 14 in)

# Complementary Grounds

For a complete change, and one that really stimulates the optic nerves, try a painting which is actually based on complementary colours. For example paint a landscape, which is basically green, on red paper; some rusty farm machinery – browns and reds – on green paper; a vase of yellow and gold roses on violet paper; a seascape – blues and blue-greens – on orange paper. The results can be quite stunning, producing an overall vibrancy of colour difficult to achieve on neutral grounds. In my painting *Still Life, Bowl of Fruit*, I chose bright blue Canson (No. 590) to get maximum buzz from the yellow bananas and the oranges. The dark red apple also works well against the green apples. A strong ground helps to unify the painting and I have let the blue shine through in many areas, particularly in the bowl, bananas, orange and the shadows on the cloth. Note the orange reflected in the red apple.

A lot of fun can be had rubbing bright pastel onto a sheet of stretched watercolour paper and merging the colours with water using your fingers or a brush. This produces some very interesting effects which can be developed with heavier applications of pastel when the underpainting has dried; this method is particularly suited to flower painting where brilliant colours are involved. Try it on 300 lb Fabriano Artistico NOT. Apart from freeing you from the chore of stretching lighter paper, the white surface seems to impart a richer depth of colour which would be very difficult to obtain on a tinted ground.

By now you will have begun to appreciate the versatility of the pastel medium. There are really no limits, only those which are self-imposed. When you have tried the methods outlined here, play around with some of your own. Experiment, not only with techniques, but with different surfaces. Flock wallpaper produces some beautifully soft images. Coloured tissue paper, torn and glued onto your support, is excellent if you like more abstract designs. By the way, have you tried the pavement outside the National Portrait Gallery?

Stoglumber Church, Noon 17/7/90

# Mounting and Framing

It is always helpful to have a few single mounts cut to the size of your paintings. I have four standard ones and I often slip one over my painting during the final stages to see how it's shaping up. A mount not only sets the painting off nicely but also helps to throw up any errors.

When I feel I've said enough – before the overworked stage – I remove the mount and give the back of the painting board a couple of hefty bashes with the heel of my hand. If any particles of pastel are going to come off this helps them on their way. To make doubly sure I place the painting on a table and lay a sheet of layout paper over it. Holding the paper with one hand I press down very firmly with the palm of the other, paying particular attention to the dark areas which cause most of the trouble. This removes any loose pastel without damaging the painting.

When the time comes to frame your pastels use a double mount. This not only provides the necessary air space between the surface of the painting and the back of the glass, thereby reducing the possibility of smudging, but the coloured inner mount should echo a colour in the painting. Incidentally, it is not necessary to tape your painting down on all four sides when fixing it to the back of the inner mount. This restricts the natural expansion and contraction of the paper due to changing humidity, and causes cockling. It is only necessary to fix the painting along the top edge, allowing it to hang down like a blind. Archival tape, or best quality masking tape will do, but never be tempted to use Sellotape. It loses its stick after two or three years with embarrassing results! Good picture framers are conversant with these procedures but others, unhappily, are not.

# Conclusion

If my enthusiasm for pastel has rubbed off on you during the previous sections I shall feel that the effort has all been worthwhile. However, reading and studying books is only part of the answer. Painting is ten per cent inspiration as well as ninety per cent perspiration! Remember that there is no substitute for the sketchbook. The more we draw, the more we see. Drawing sharpens our powers of observation and fills our memory banks with information which we can use at a later date. The more practice you put in, the more success and satisfaction you will get out. Cézanne put it very succinctly with the words 'We must be more than copiers. We must not be slaves to nature, but take from her what we will.' He knew. May your own exploration into pastel give you much pleasure. Enjoy it and good luck.

# Further Reading

*Painting with Pastels*
Edted by Peter D. Johnson
Search Press, 1994

*Learn to Paint Pastels*
John Blockley
Collins, 1980

*Learn to Paint Trees*
Norman Battershill
Collins, 1990

*Painting with Pastels*
Aubrey Phillips
B T Batsford, 1993

*Pastels Masterclass*
Judy Martin
HarperCollins, 1993

*The Encyclopedia of Pastel
Techniques*
Judy Martin
Headline, 1992

*Pastel Painting Techniques*
Guy Rodin
Studio Vista, 1987

*Creative Painting with Pastel*
Carole Kitchen
HarperCollins, 1990

*Pastels Workshop*
Jackie Simmonds
HarperCollins, 1994

*Painting Gardens*
Norman Battershill
B T Batsford, 1994

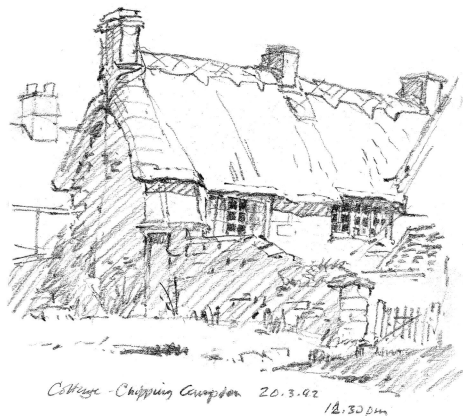

Cottage - Chipping Campden 20.3.92
12.30 pm

125

# List of Suppliers

If you have enjoyed reading this book, there are two sixty-minute videos, *Pastel Landscapes* and *Progressing with Pastel*, in which Barry Watkin can be seen in action, painting scenes similar to those in this book. The videos are available from:

APV Films
6 Alexandra Square
Chipping Norton
Oxon OX7 5HL
Tel: 01608 641798

## UK

Winsor and Newton
51 Rathbone Place
London W1

Caran d'Ache
Jakar International Ltd
Hillside House
2-6 Friern Park
London N12 9BX

East London Graphics
86-99 Upton Lane
London
E7 8LQ

London Graphic Centre
107-115 Long Acre
London WC2

UDO City
69-85 Old Street
London EC1V 9HX

Cornelissens
105 Great Russell Street
London WC1B 3RY

Artworks
28 Spruce Drive
Paddock Wood
Lightwater
Surrey GU18 5YX

Pullingers Stationers
109 West Street
Farnham
Surrey GU9 7HH

Hearn & Scott
10 Bridge Street
Andover
Hampshire SP10 1BH

R S Frames
4 Broomfield Road
Sunbury-on-Thames
Middlesex TW16 6SW

Broad Canvas
20 Broad Street
Oxford OX1 3AS

Daler Rowney
PO Box 10
Bracknell
Berkshire RG12 8ST

Gemini Craft Supplies
14 Shakespeare Street
Newcastle Upon Tyne
Tyne & Wear NE1 6AQ

James Dinsdale Ltd
22-24 Kings Charles Street
Leeds LS1 6LT

Merseyside Framing & Arts Ltd
62-64 Wavertree Road
Liverpool L7 1PH

John E Wright & Co
15 Brick Street
Derby DE1 1DU

Everyman
13 Cannon Street
Birmingham  G2 5EN

Rod Waspe
11-13 Bank St
Rugby  CV21 2QE

Colemans
84 High Street
Huntingdon
Cambs  PE18 6DP

Windsor Gallery
167 London Road South
Lowestoft
Suffolk  NR33 0DR

Doodles
61 High Street
Newport Pagnell
Bucks  MK16 8AT

Framework
63 Pembroke Centre
Cheney Manor
Swindon
Wiltshire  SN2 2PQ

Dicketts
6 High Street
Glastonbury
Somerset  BA6 9DU

Mair & Son
46 The Strand
Exmouth
Devon  EX8 1AL

Frank Herring and Sons
27 High West Street
Dorchester
Dorset

CJ Graphic Supplies Ltd
32 Bond Street
Brighton
Sussex  BN1 1RQ

Forget-Me-Not
70 Upper James St
Newport
Isle of Wight  PO30 1LQ

Elsa Frisher
9 St Peter's Square
Ruthin
Clwyd  LL15 1DH

Inkspot
1-2 Upper Clifton Street
Cardiff
South Glamorgan
CF2 3JB

Alexanders Art Shop
58 South Clerk Street
Edinburgh  EH8 9PS

Burns & Harris
163-165 Overgate
Dundee DD1 1QF

Millers Ltd
11-15 Clarendon Place
St George's Cross
Glasgow G20 7PZ

The EDCO Shop
47-49 Queen Street
Belfast  BT1 6HP

# USA

Aiko's Art Materials
Import
3347 N.Clark Street
Chicago
Illinois 60657

Badger Air-Brush
Company
9128 West Belmont
Avenue
Franklin Park
Illinois 60131

Fletcher-Lee & Co
PO Box 007
Elk Grove Village
Illinois 60009

Printmakers Machine Co.
PO Box 71
Villa Park
Illinois 60181

Dick Blick
PO Box 1267
Galesburg
Illinois 61402

Pearl Paint Company
307 Canal Street
New York 10013

New York Central Art
Supply
62 3rd Avenue
New York 10003
Artist's Connection
20 Constance Ct
PO Box 13007
Hauppauge
New York 11788

Winsor & Newton
PO Box 1396
Piscataway
New Jersey 08855

The Italian Art Store
84 Maple Avenue
Morristown
New Jersey 07960

Art Supply Warehouse
360 Main Avenue
Norwalk
Connecticut 06851

The Artist's Club
5750 NE Hassalo Street
Portland
Oregon 97213

Texas Art Supply
2001 Montrose Boulevard
Houston
Texas 77006

Sax Arts and Crafts
PO Box 51710
New Berlin
Wisconsin 53151

Perma Colour
226 E Tremont
Charlotte
North Carolina 28203

Co-Op Artist's Materials
PO Box 53097
Atlanta
Georgia 30355

Chroma Acrylics, Inc
205 Bucky Drive
Lititz
Pittsburgh 17543

Conrad Machine Co.
1525 S. Warner
Whitehall
Michigan 49461

HK Holbein, Inc.
PO Box 555
Williston
VT 05495

Ziegler
PO Box 50037
Tulsa
Oklahoma 74150

Art Express
1561 Broad River Road
Columbia
SC 29210

Pentel of America, Ltd
2805 Columbia Street
Torrance
California 90503

Napa Valley Art Store
1041 Lincoln Avenue
Napa
California 94558